Amphoto's Guide to

DIGITAL
BLACK AND WHITE
PRINTING

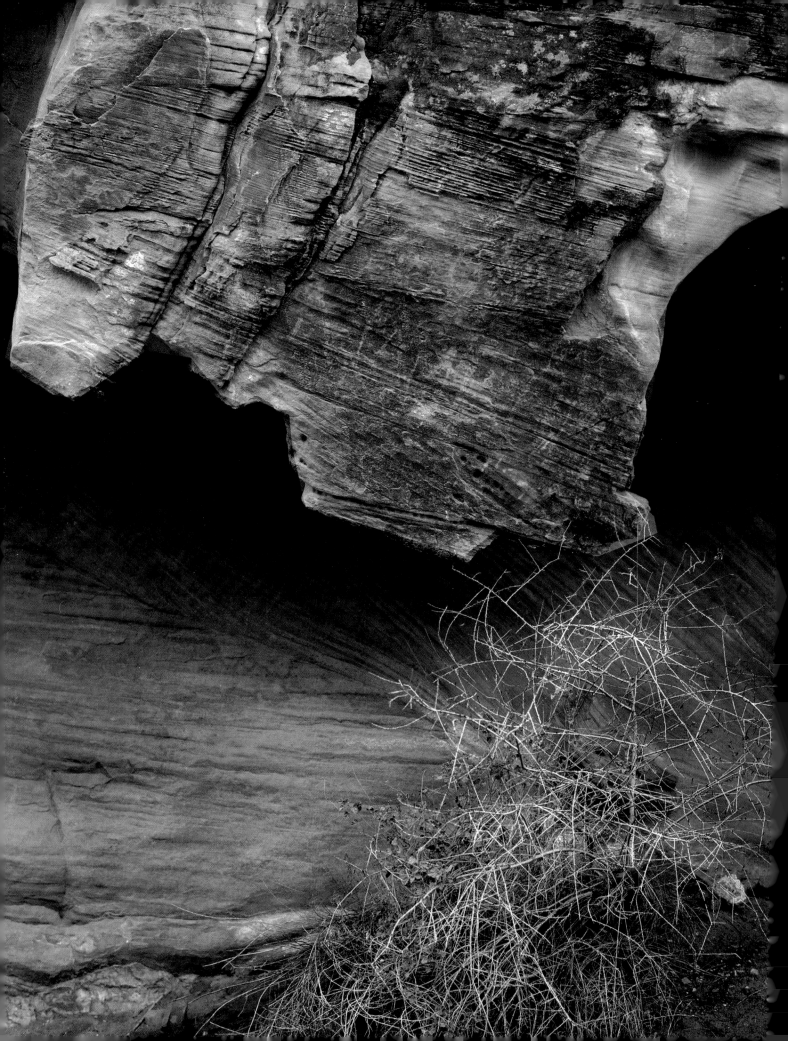

Amphoto's Guide to

DIGITAL
BLACK AND WHITE
PRINTING
Techniques for Creating
High Quality Prints

GEORGE SCHAUB

BetterPhoto.com
Book Selection

AMPHOTO BOOKS

An imprint of Watson-Guptill Publications
New York

First published in 2005 by Amphoto Books
An imprint of Watson-Guptill Publications
A division of VNU Business Media, Inc.
770 Broadway
New York, NY 10003
www.wgpub.com
www.amphotobooks.com

Senior Acquisitions Editor: Victoria Craven
Senior Developmental Editor: Stephen Brewer
Senior Production Manager: Ellen Greene

Text and illustrations copyright © 2005 George Schaub

Library of Congress Control Number: 2005925108

ISBN 0817470719

Printed in the U.S.A.

1 2 3 4 5 6 7 8 9 10 / 14 13 12 11 10 09 08 07 06 05

To Grace and the visions and travels we have shared.

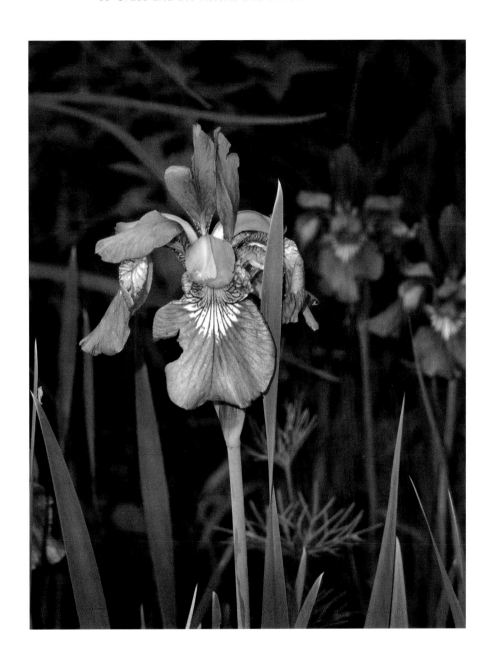

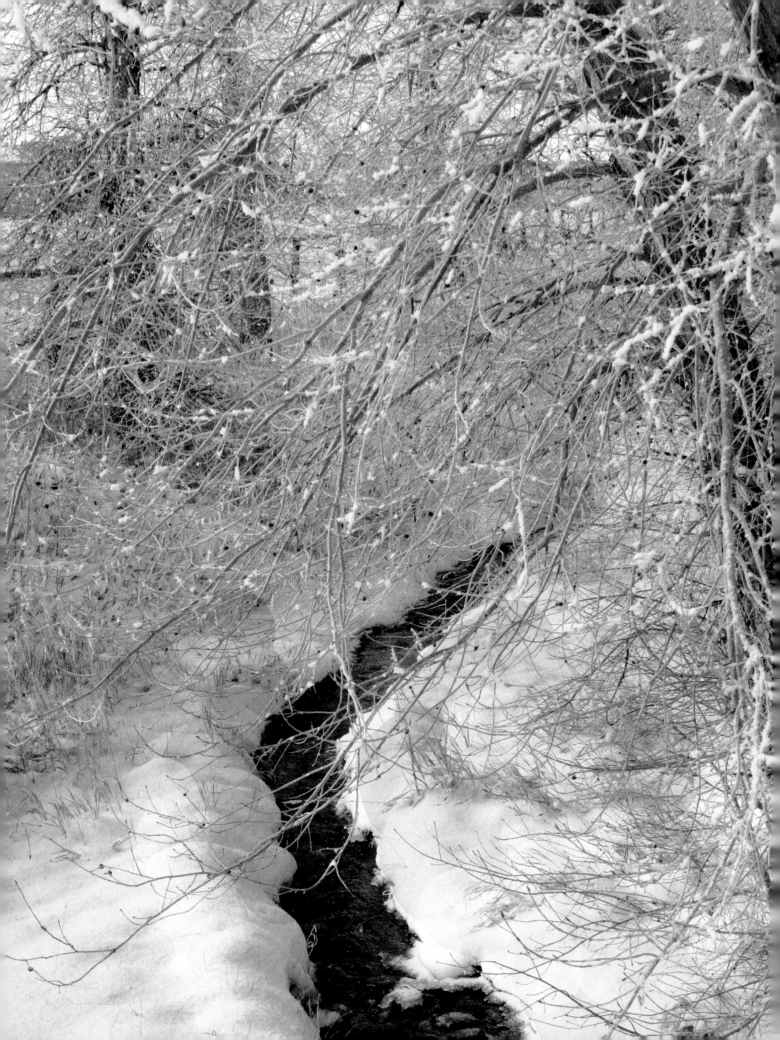

CONTENTS

INTRODUCTION

My goal in this book is to give you the tools you need to do just about anything you want to do with an image. I borrow from many different styles and schools of printmaking and especially from the conventional darkroom. Even so, I don't expect that your digital prints will replace those you might make in the darkroom, any more than they'll replace the feel and look of an etching, woodblock print, or platinum print. Digital technology allows us to emulate those styles, but each print you create should belong to you and be a unique manifestation of how you perceive the world.

Printing is an integral part of your photography and completes the creative circle you initiated when you first snapped the shutter. When you learn what it takes to make a good print, you begin to make better pictures in the camera, if only to avoid the hassle of always correcting poor exposures. In this book I provide effective techniques that you can use to make expressive prints that both satisfy you and encourage others to share in your vision. Printing is subjectivity with an underlying discipline of technique, and an important part of learning to print is knowing how you want the final image to look. This

means that you should first determine the character of the final print you desire, then go about using your tools and techniques to make the print express those visual ends. This method allows you to fine-tune your work and add those touches that impart a distinctive and effective evocation of each and every subject and scene.

I have been using this form of printmaking for almost seven years, which I suppose makes me a veteran. Before that, I pursued a passion for silver black-and-white printing—and made a living from it—for almost twenty years. In this book I have distilled a series of techniques from my experiences, which at times have been fruitful as well as frustrating, to ease the pain and make digital monochrome printing fairly easy for you. If you follow the basic steps I cover and apply the techniques to your own work, I trust that you'll find that they allow you full expression without too many complications.

My approach is to make the craft of digital printmaking as simple as possible. This does not mean that I take the path of least resistance. I have too many new things to learn and processes to work with to say that the path is

The range of tonal values, the play of contrast, and the overall impression of this print made from a scanned color slide all speak to the effectiveness of expression of the digital printing medium. Note the textural highlight, open shadows, and play of light that inform the image.

easy. But I do shy away from special effects for their own sake and rarely use artistic filters to jazz up an image. As I try to demonstrate throughout this book, I do my best to make the process uncomplicated. My feeling is that as photographers we should not spend all our time in front of a computer screen. But we should use the tools and techniques digital technology provides to get the most we can from each image.

I assume that you are not reading this book, and making prints, in order to spend all your time wrestling with a computer and software programs. I only began to enjoy working with digital photography when I developed a method for getting what I wanted relatively quickly—one that did not get me mired in endless manipulation and multiple steps. When I used to teach silver printing I was conscious of paper waste (and expense) and used a three-print-to-final-print approach (test strip print, study print, and final print). I don't have much concern about paper waste here, as the screen or virtual image becomes the test and study print, but I do have a concern about another type of waste—wasted time.

Effective prints rely on a number of factors—tonality, contrast, and exposure—to express fully what you want to say about the subject in the photograph. In some cases this might mean working with a high-contrast rendition; in others it might mean working with a full tonal range or even obscuring parts of the image to create a center of light on your main subject. You might add a color tone to one image that would be totally out of place with another. When you first begin printing you may find it difficult to decide upon the approach to take. The common wisdom is that form should follow function; let the subject matter guide you on your way. In truth, there are no hard-and-fast rules in this game, and you might find that your decisions are based more upon how you feel when you're printing than on any dictum laid down here or elsewhere. Your final decisions should be more emotional than academic, based more on who you are than whom you admire. I can assure you of one thing—over time, especially over the course of a number of years, how you print an image today will be quite different from how you see it and print it later.

This print is from a negative exposed in 1972. Having printed it numerous times in the conventional darkroom, I can attest to the fact that I had more control, and a much easier time of it, when I printed it using digital techniques in the late nineties. Many photographers will use the digital darkroom to revisit old negatives and slides and make new interpretations.

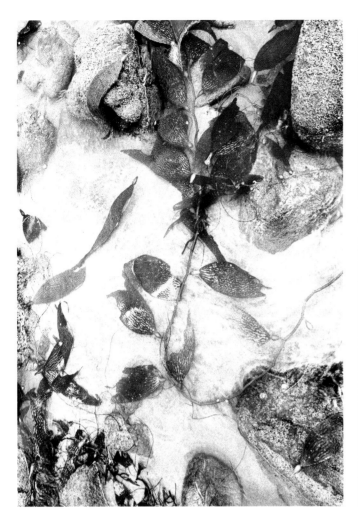
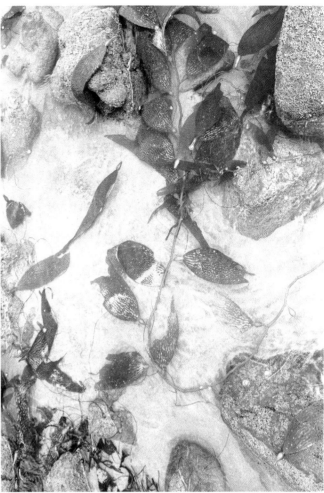

The ease with which you can vary the values and tones in your image is what makes digital printing so creative. In the traditional darkroom you can see the result of changes only after processing a print, but digital technology allows you to experiment in "real time" with every essential printing control and try many different variations. The contrast and exposure controls will be familiar to traditional darkroom printers, but they become so much easier to use in the digital environment.

KEEP A PRINT DIARY

One of the best aids in becoming a good printmaker is keeping a print diary. This collection might include images you've made of different subjects on a wide variety of papers, all printed with different exposures and contrast interpretations. Your diary might include different types of images—a nature scene, an urban landscape, a portrait, a fashion shot, an abstract, and so on. When you're working on a print and stuck about which way to go, take the time to pull out these archetypes and consider your approach. A catalog from a gallery show might open your eyes; a new approach might emerge from studying old hand-colored prints or charcoal studies. Do what excites you and you won't go wrong. The great thing about digital technology is the way it encourages risk taking and experimentation, a process that can often lead to finding your own personal style.

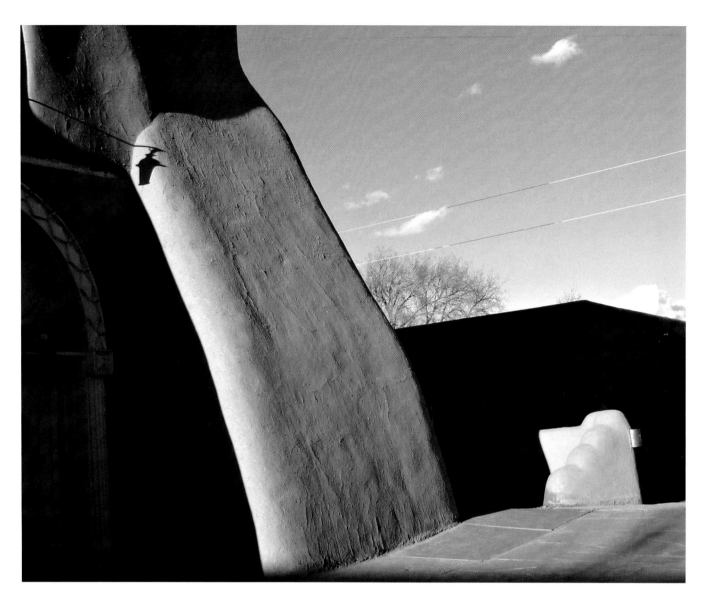

Black-and-white photography offers many expressive possibilities, thanks to the tonal range of the exposure and the ability to manipulate the tonal values in software. As with film, in the digital format exposure, development (image processing), printing choices, and, of course, subject matter make for a versatile, powerful medium. All of these images are about the interplay of light and subject matter. By exposing for bright highlights I accentuated line and form in a building (above). By seeing the possibilities in black and white I created a graphic representation of torn posters (right) in image processing. By studying other mediums I transformed a dock piling (opposite) to an emulation of an abstract expressionist's monochrome study.

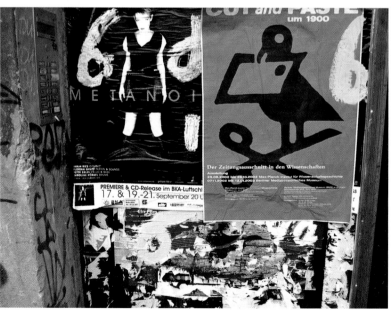

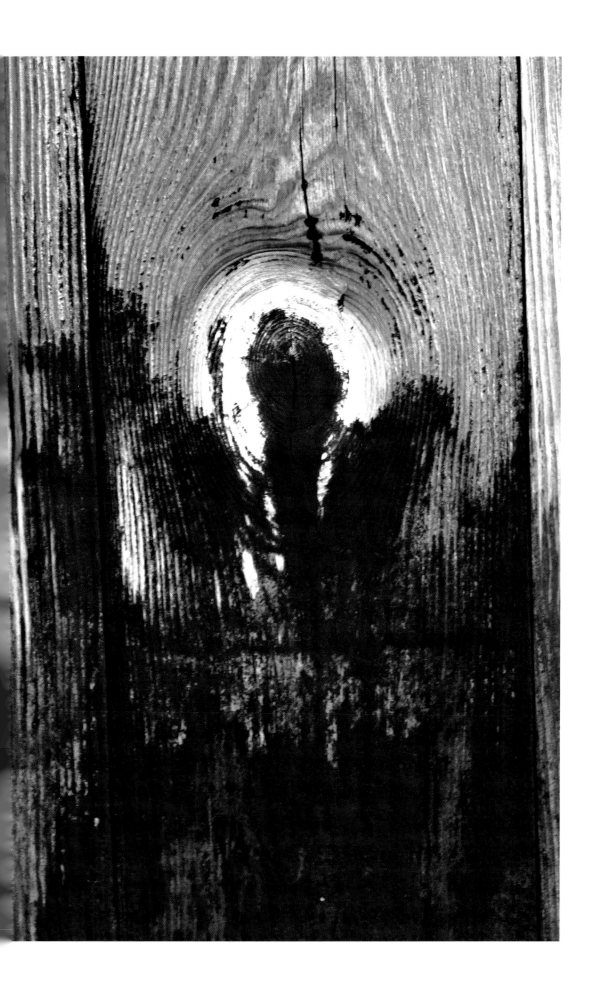

Finally, a few words about software. Throughout this book I make references to Adobe Photoshop software, the lingua franca of the digital darkroom world. My references are not version specific and should help you to work easily with whatever the latest manifestation of this incredible software might be when you read this book. If you have a different type of the many image-editing programs available, you can still use the techniques described in this book; you will simply have to make the translations in terminology and tools from Photoshop to the software you use.

I encourage you to apply all the tools and techniques in this book to your work. Be aware that with Photoshop and many other programs there's more than one way to reach an effect or goal; stay open to new ideas and methods, and talk with those who share a passion for printing with you. That's how I learned all the techniques here, and how I continue to grow in both my study and creative pursuits.

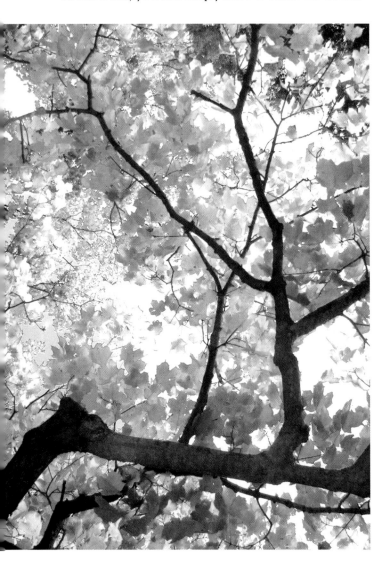 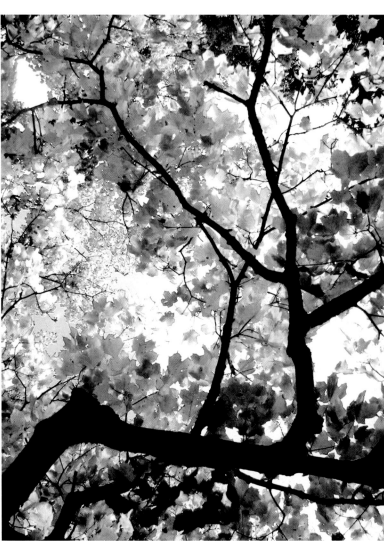

There is really no right or wrong way to interpret an image, as long as the interpretation does not interfere with the communication—that is, how you want to express a time, place, or specific subject in tones, exposure, and contrast values. I scanned this black-and-white negative, then (left to right) produced a close emulation of what a contact print might have looked like on a normal photographic paper. I also increased the contrast, then increased contrast and exposure, and finally, colorized the image. You can easily accomplish variations like these using the printing techniques covered in this book.

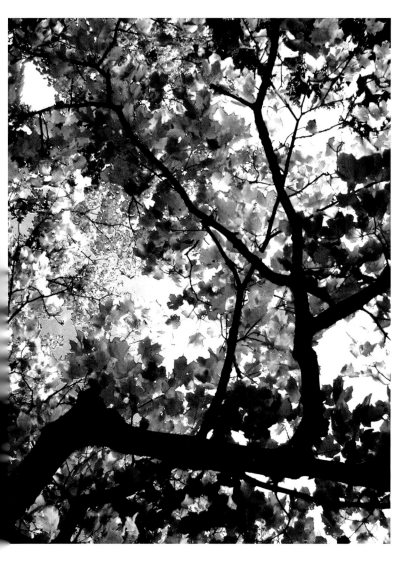
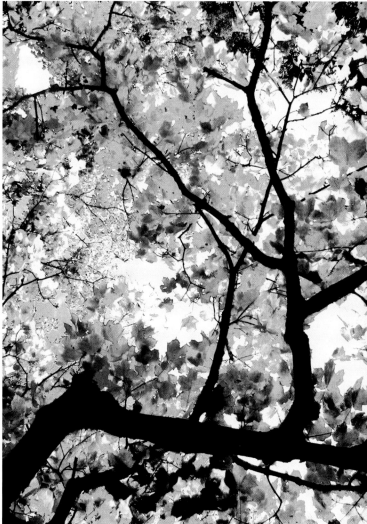

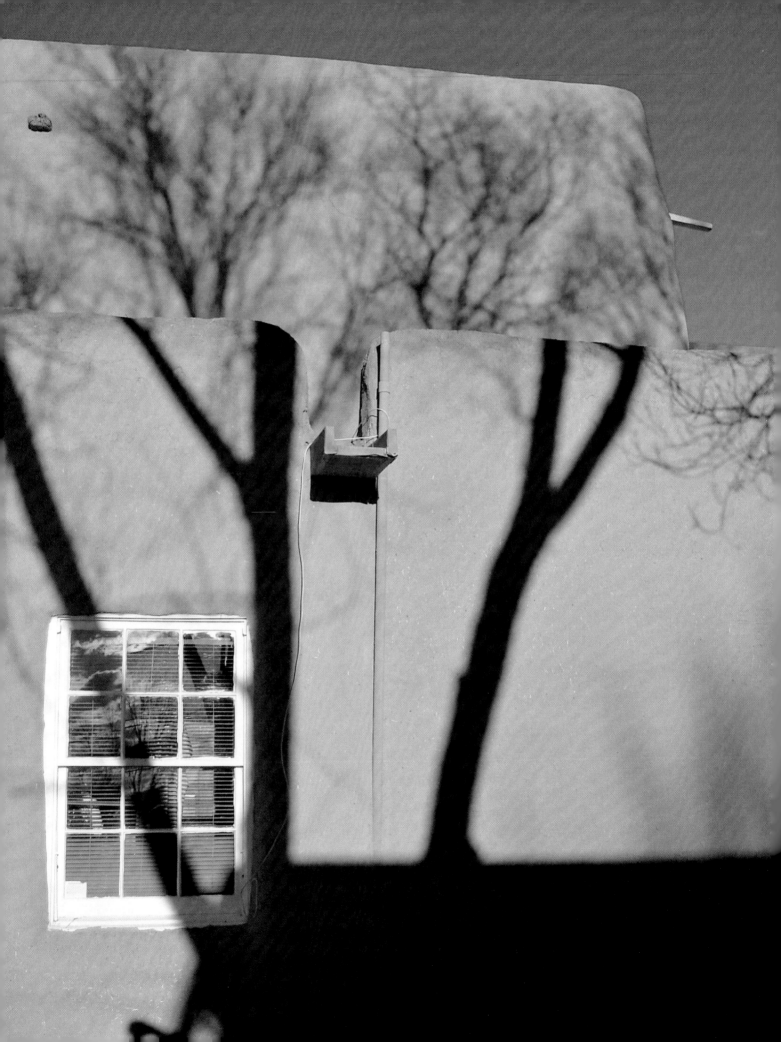

AN APPRECIATION OF BLACK AND WHITE

You may soon discover that the black-and-white print expresses your artistic vision more than color does. Black and white also has many other merits, from capturing the beauty of tonal values to evoking nostalgia.

THE POWER OF BLACK AND WHITE

Black and white allows us to see without the distraction of color, so we can approach the heart of a matter, or of a design, in its purest form.

What is it that makes black-and-white photography such a compelling visual medium? In terms of pure visual enjoyment, there is the beauty of the tonal values that so richly express the play of light and shadow—the shades of gray and the deep blacks and bright whites. The tones are versatile and can represent a stark or subtle ambiance with equal impact. For the photographer, black and white offers a great deal of creative freedom and the opportunity to express his or her artistic intent in every step of the creation of the image—from the choice of subject matter to exposure to image processing and printing. To those engaged in a serious study of, and love for, photography, black and white is of great importance. And for many who collect photographs, black and white is the medium of choice.

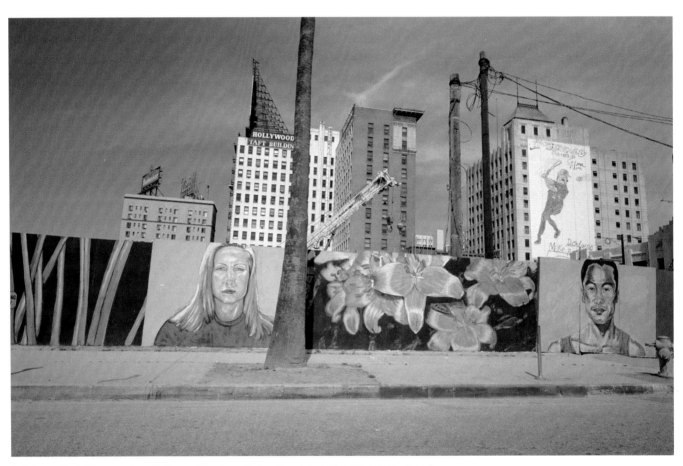

I photographed this scene from Hollywood Boulevard in Los Angeles on chromogenic black-and-white film, an excellent source film for black-and-white scanning and printing that has minimal grain and low inherent contrast. I then scanned the image and printed it out on glossy inkjet paper using a black-ink-only setting.

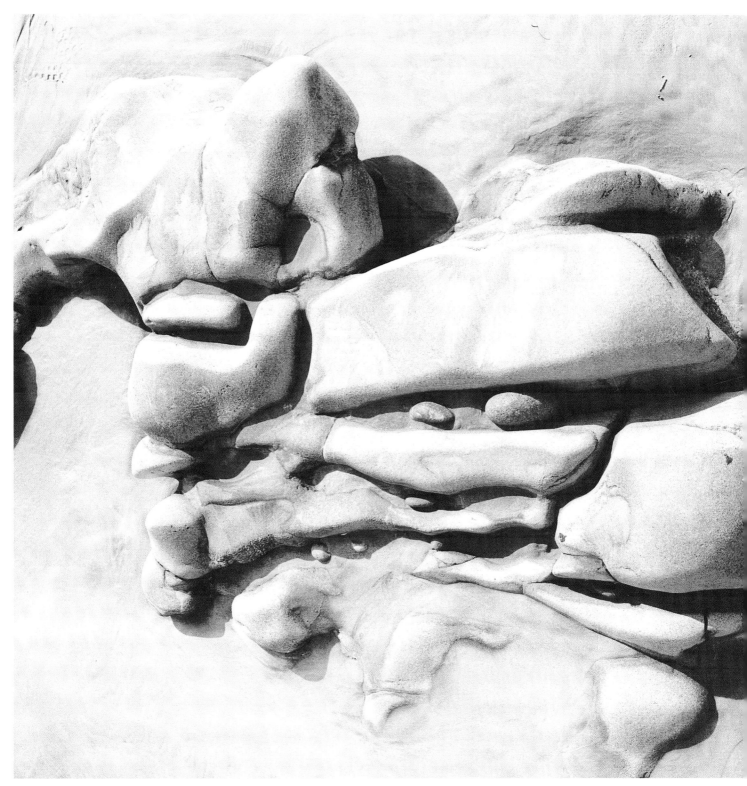

You can make prints with certain keys, similar to musical values. A low-key print emphasizes darker values and mood. A high-key print works with middle and lighter shades of gray in which highlights are muted and textured, providing an ethereal feel. This image of rocks on Torrey Pines Beach in southern California is in high key, with open shadows.

THE BLACK-AND-WHITE PHOTOGRAPHIC PRINT

A successful print communicates the thoughts and feelings of the photographer at the moment the shutter is snapped.

Often, a print faithfully depicts a scene's original quality of light. Or, a print can reinterpret the scene to enhance the image or to add further visual expression. The photographer makes these reinterpretations while exploring the image's visual possibilities, finding ways to go beyond what was glimpsed, or intuited, when the shutter was first released.

The ability to enhance the moment, or to reinterpret the vision, is one of the most exciting aspects of the art and craft of photography. This artistic freedom is the key to enhanced communication through photography. It can bring even greater creative forces—introspection and retrospection—into play.

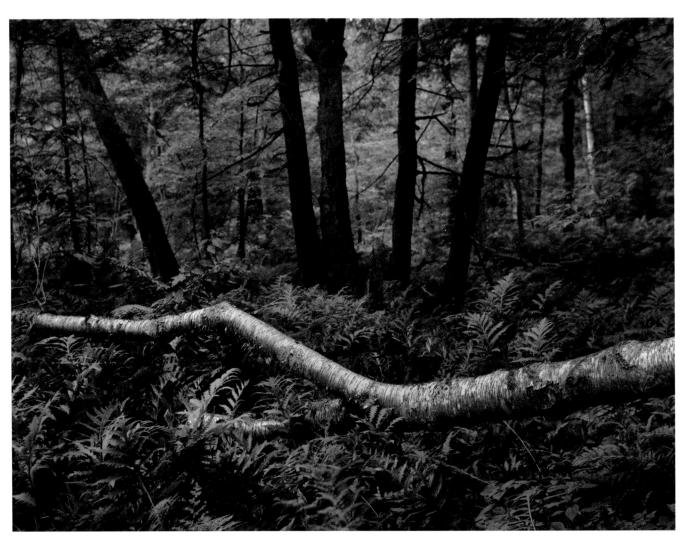

This forest scene, from a scanned medium-format negative, was photographed under fairly flat (low-contrast) lighting conditions. By manipulating the values I was able to establish a visual rhythm of light and dark tones.

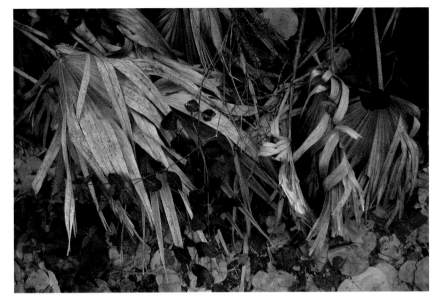

Expressive printing is a personal approach that can involve stylistic decisions or simply finding a unique look for a body of work. In this sequence, the original exposure, made with a digital camera using Raw mode, is filled with tonal potential—that is, receptive to creative interpretation. The tonal set is enhanced by increasing contrast (middle). A more emotional approach is shown at the bottom, where freehand dodging decreases density and burning increases density. Your interpretation of the same scene would be different from mine. That's what makes printmaking so exciting—the ability to render a scene in so many different, personal ways. I often seek out such scenes when I photograph, knowing they will allow for many interpretive approaches.

SAVOR THE NOSTALGIA

Scanners, digital software tools, and printing techniques allow us to save a wealth of treasures from the past.

We all know the range of emotions that black-and-white photographic images evoke. We might enjoy a warm feeling of nostalgia when viewing old family photos or classic black-and-white movies, or share a sense of history in seeing familiar news photos and portraits that have become icons of their age. Affordable scanners make it easy to preserve fading prints and negatives, and digital printers yield prints that can last as long as their silver and dye counterparts.

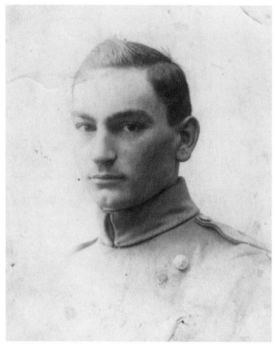

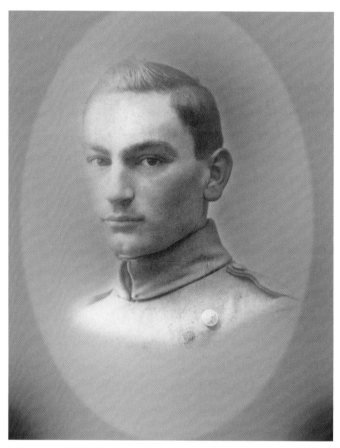

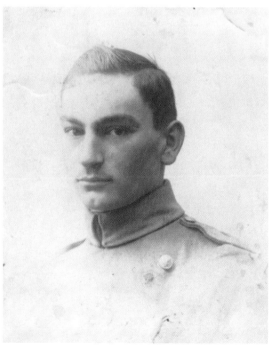

Using a scanner and digital retouching techniques, you can rescue old images that may have become damaged and/or faded. You can then share these precious images and, more important, pass them on to future generations. My family believes that this is a photograph of my grandfather, killed in World War I. I scanned the original and did some quick retouching, then created a toned image for framing.

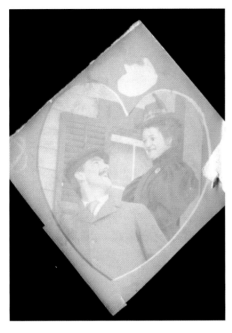

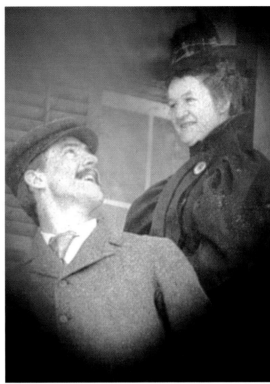

Digital-imaging software can work miracles. I found this print, so faded it's about to disappear altogether, in an album that, from the clothing, seems to be from the late 1890s or early twentieth century. I then scanned it and used image-editing software tools to heighten contrast and enhance density. As a result, these people once again share a happy moment in their lives. While this picture awaits more work, the ability of scanners and software to rescue images from obscurity or loss is a great boon to historical researchers and family photographers.

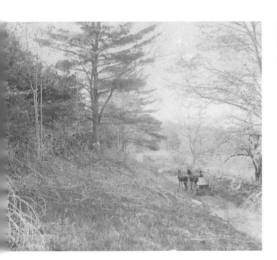

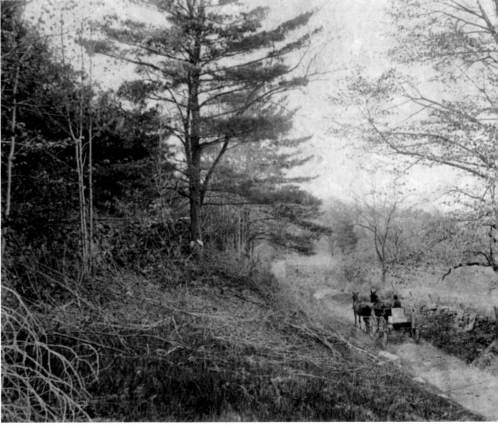

I found this photo depicting a simpler time and idyllic place at a flea market. The original print was on very thin paper and might be an example of a cyanotype, or perhaps it was just toned blue using a long-forgotten chemical mix. After scanning and retouching, and a slight alteration in image color, the picture can be appreciated a hundred years from now.

STUDY THE LEGACY

One of the best ways to understand what makes a
print effective is to study the work of the masters.

Photographers, printmakers, and other artists may well
have inspired you to pick up a camera, or brush, or a stick
of charcoal in the first place. I draw much of my inspira-
tion from diverse artists—from the Photo-Secessionists, a
group founded in 1902, to modernists such as Paul
Strand, Aaron Siskind, and Minor White. I also am in-
spired by the monochrome studies of Edward Hopper and
the etchings of Rembrandt, which I first viewed in some
dim museum gallery when I was young. Digital mono-
chrome printing, the subject of this book, draws upon vi-
sual references that include all the visual arts. There's as
much to learn from studying seventeenth-century Dutch
etchings, nineteenth-century Japanese woodblock prints,
or alternative photographic processes such as platinum
prints, gum bichromate prints, and even daguerreotypes
as there is from looking at modern digital prints.

As you get involved in your own work, make time to
go to museums and gallery shows, and seek out work you
admire. If a print grabs you, try to understand what about
it makes you stop and study. Of course, the subject matter
is important, but also observe how the craftsperson has
used printing technique as an essential part of the overall
communication of the image.

Though books of collections and monographs are great
ways to get to know the works of a number of different
artists, nothing quite matches the impact of having an ac-
tual print in front of you. Regardless of how well the book
is printed, there's always a generation gap between the
"live" print and the printed page. If you've ever stood be-
fore a real Rembrandt, a Raphael, a Paul Strand, or a
George Tice and compared the work to how the image
appears in a book or catalog, you know what I mean.

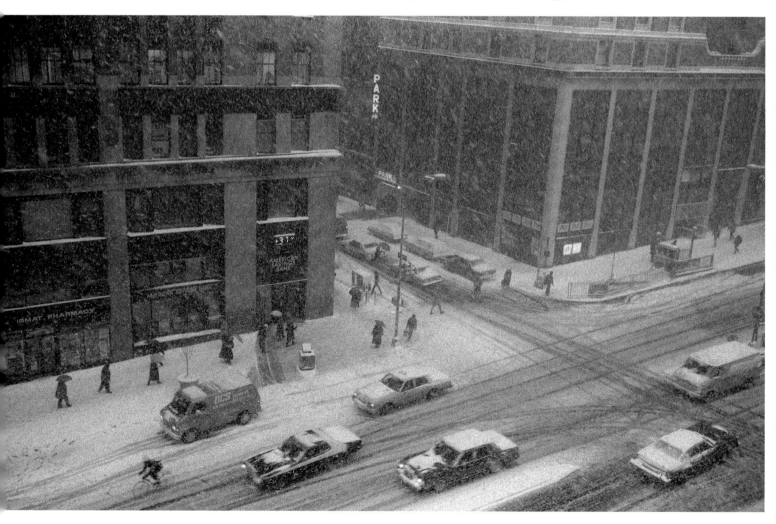

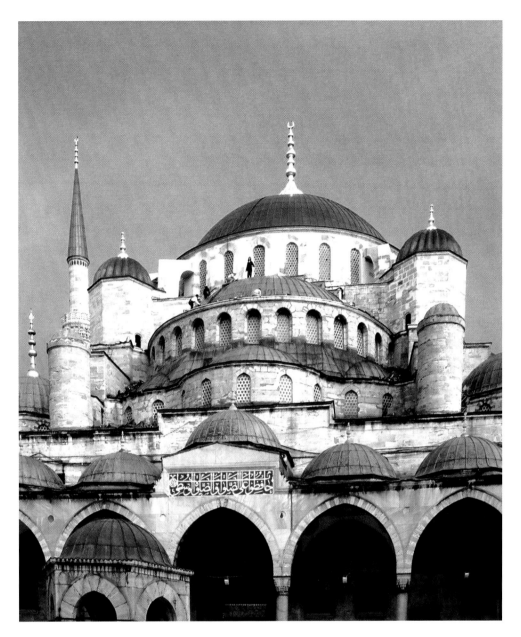

Digital photography allows you to re-create the look of old prints, graphics, and now-extinct photographic techniques. This image of a grand old mosque in Istanbul could be a nineteenth-century albumen print; however, I made it with a digital camera last year and printed it with an inkjet printer.

Similarly, the photo of New York in winter on the opposite page references the tonal and image color rendition of a Photo-Secessionist print from the turn of the nineteenth century.

WHAT TO LOOK FOR IN A PRINT

Look at how the tonal scale (from white through the grayscale to black) is handled and consider whether high or low contrast is important. See how the edges are handled. Is there a strong, centered play of light, or is there a diffuse feel to the image? How are details in the highlight and shadow areas handled, and does this add to the impact of the scene? Is the light play real, or is there a tricky, experimental vision at play? Does the overall texture of the image play a role (the smoothness or the rough quality of the grain, or "noise")? And how does the type of photographic paper itself influence your impression?

THE ART AND THE CRAFT

Art and craft are delicately balanced in every stage of creating a black-and-white image. Your goal is to produce images that will touch the viewer and express your artistic vision.

By definition, art seeks to evoke response and to communicate ideas and feelings through creativity; craft refers to the techniques that make for effective art. Printing technique, part of the craft of photography, serves your expression—your vision and the image created from that vision. You create a digital print by laying down ink on paper to create an image. Digital technology can enhance your artistic abilities, because digital techniques allow you to emulate the look of any process, old or new, with relative ease.

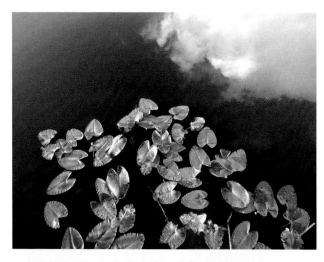

When you first open a digital-image file you should take some time to consider where you want it to go. This scene (left) needed some contrast adjustment, but I could grasp its potential only after I took the first step and enhanced the tonal relationships. This became a springboard for other options, here an expansion of the cloud reflection through use of the clone (Rubber Stamp) tool and a unification of the values of the sky and an overall contrast adjustment.

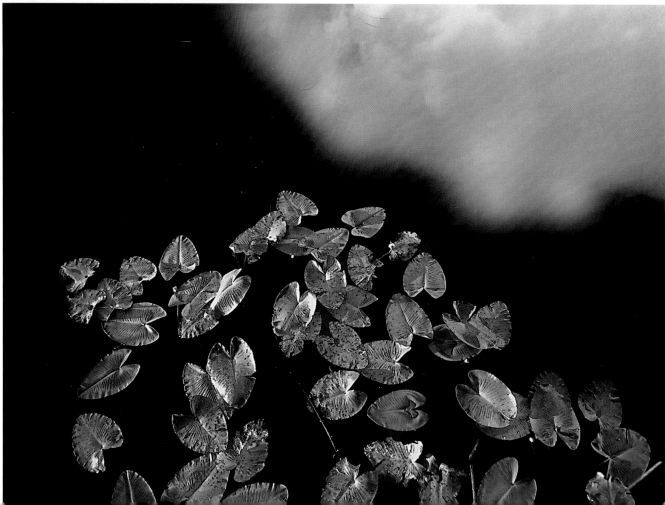

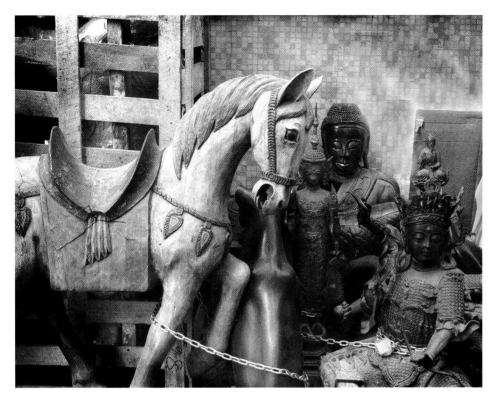

◀ There's a long tradition of applying or adding color to monochrome images, a technique made easy in the digital darkroom. I converted this photo of an antiques store display from grayscale (black-and-white) to RGB (color) mode and added a sepia tone using the Variations tool.

▼ To lend the look of an old, faded postcard to this rural scene I worked with painting tools and chose various color opacities, again with the grayscale image mode converted to RGB. Using a painting tool set at low opacity allows all the details of the scene to come through.

Black and white is a bit of a misnomer, as many monochrome images can be just as effective when imbued with an overall color tone. Chemical toning has a time-honored tradition within this craft, ranging from the deep blue of cyanotype to the nostalgic feel of sepia or brown toning. The digital darkroom allows you to explore many different toning possibilities, all with ease. This photograph of a high-mountain lake in Montana has been printed with a light, warm-brown tone (above) and with a cool blue color cast. Each photo will benefit from its own color-toning approach, depending on how you want to interpret the image.

THE ARTIST AND THE CRAFTSPERSON

Digital photography is not like snapshot photography, in which picture-taking is the end of the process for the photographer. With digital photography you can make your own prints to express your artistic vision, to capture the character of the image, and to convey the fun and excitement of the work.

An important part of making good black-and-white prints is understanding what goes into an effective print—for you. Before you can take that personal journey you must understand the power of the black-and-white medium and grasp the terms and visual associations that make black and white work. You have to understand what, in your eyes, makes a print effective. You will come to understand how printing affects the way in which a photographic subject is seen and to appreciate the creative choices you have as photographer. As you begin to create images, you'll see how deliberate choices and an educated intuition will have an important effect on the visual and emotional impression that each image makes.

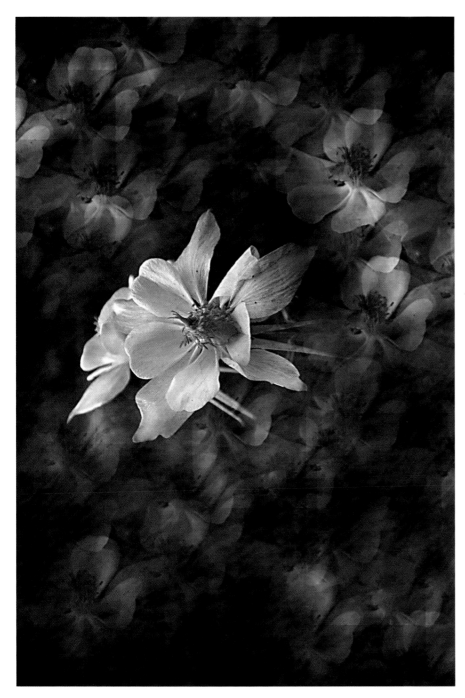

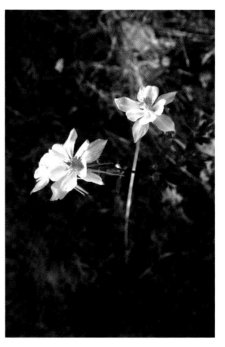

Look for the picture within the picture, then experiment with patterns, tones, and cropping. I cropped this simple shot of two flowers in a field to one flower, and after some contrast adjustment repeated the pattern using the clone tool in various opacities.

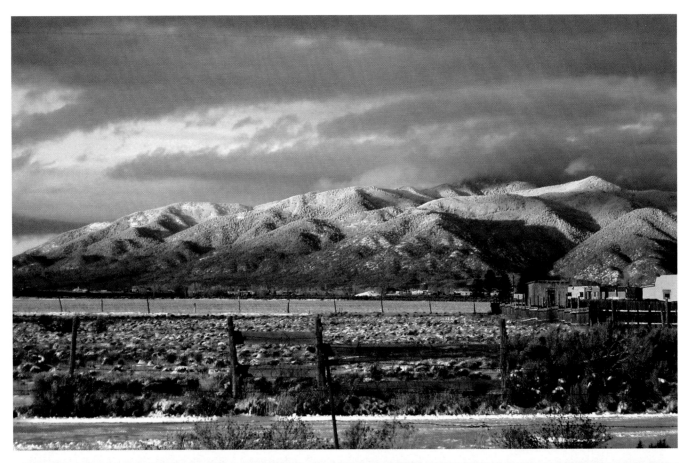

Each of these prints was originally photographed with a digital camera set in RGB mode. In digital, converting from color to black and white is quite simple, with numerous paths available, depending on the degree of control you desire. This ease of conversion means that you can photograph with the intention of working in monochrome, even though you record in color, or you can work with color slides and negatives you may have photographed in the past and revisit them as black and white. In addition, when you are working with monochrome images in the computer you can view and work on them in RGB mode. This makes it simple to add color tone or to selectively add color, muted or bold, to any part of the image you desire. The flexibility means that you can bring creative controls to your printing that in the past were at the least laborious and often impossible to attain.

THE ELEMENTS OF A BLACK-AND-WHITE PRINT

Tonal Scale

Contrast

Exposure

Tonal Consistency

Highlight Control

There is no right or wrong way to make a print, but understanding how a print works and what to aim for will make you a better printer and ultimately a better photographer in the bargain.

TONAL SCALE

The wide range of tones creates shadows and highlights and lends a photographic image its emotional value.

Photographic images are distinguished by the illusion of continuous tone, the creation of an image through the use of black, grays, and white that flow through what you could call a grayscale spectrum. Of course, not all black-and-white photographic images display a full tonal range. For their emotional power they might rely instead on an emphasis on deep tones (dark grays and blacks, or low-key images) or high tones (lighter grays and whites, or high-key images), or even just black and white, with few or no gray tones at all. They may also be toned or have a decidedly brown, sepia, or magenta color cast. Some may even have a dash of color thrown in.

The range of tones that are reproduced in a print is referred to as tonal scale. Tones are the blacks, whites, and shades of gray that are available in black-and-white image making. You can't create tones that don't exist on a negative or in an image recorded by the digital sensor, so you want to record as full a range of these tones as possible when you take a picture.

When you make an exposure you are recording the brightness values that exist in the scene. Bright areas are called highlights and darker areas are called shadows.

Two terms to keep in mind are significant highlight values and significant shadow values. Significant highlight values refer to the brightest areas in the scene that contain texture (as opposed to spectral highlights, which are glints of light, like those sparkling on a pond in the late afternoon). Significant shadow values refer to the darker areas in which detail or image information appears, and deep shadows are deep tones without detail, like the shadows cast on a bright day.

Of course, your photo contains more than just bright and dark areas: A whole range, or scale, of tonal values goes from near-black to near-white, with myriad possibilities in between. Some photographers differentiate these shadings into eleven zones, numbered 0 through 10 (with 0 being pure black and 10 being pure white). In digital, the generally accepted tonal grayscale is composed of 256 levels. Most importantly, the tonal scale recorded during an exposure defines the range of possibilities within the print. If you have recorded a broad scale of tones, you can generate a broader range of tones on the print, or at the very least, produce a better print than you could if fewer tonal values were recorded.

A common complaint about digital prints is that they cannot reproduce the values seen in a silver print. I respectfully disagree. This digital print, made from a scanned 35mm black-and-white negative, yields a tonal range and variety that I would be more than happy to obtain from a silver print.

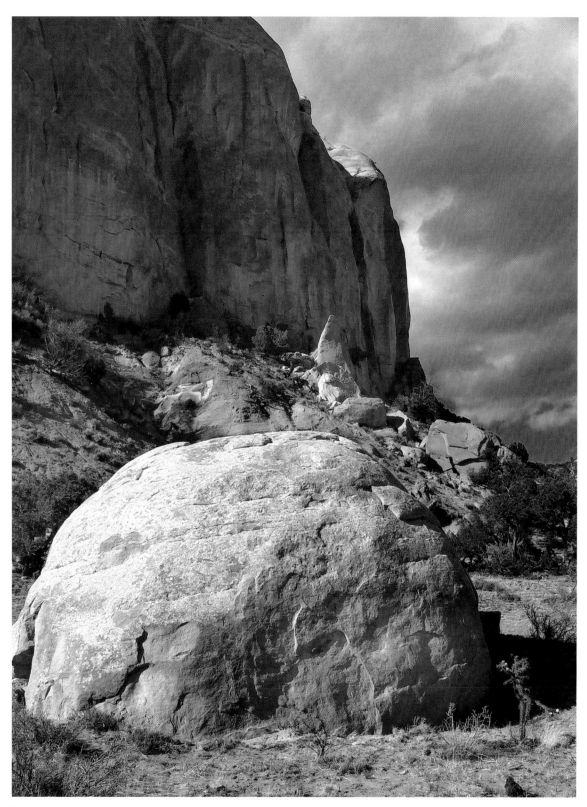

The choice of tones has a profound influence on how the image and the subject are perceived. In some cases you will want to have as full a tonal range as possible, in essence, matching the light values of the original scene. This print of a high desert scene contains a range of tonal values, from textural highlight to deep shadow. I aimed the enhancement techniques at maintaining the tonal values rather than interpreting them by making shadows deeper and highlights brighter and altering the gray values that appeared in the original scene.

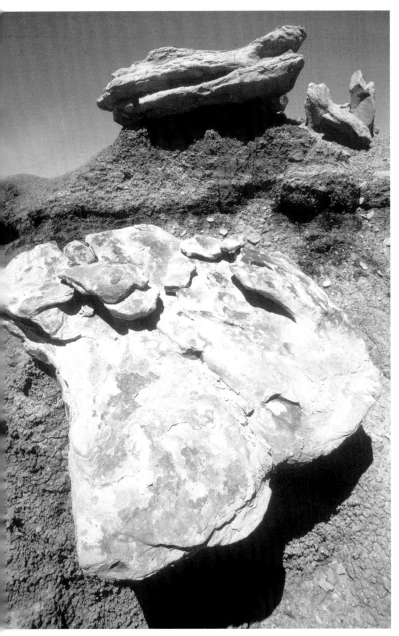

The range of tones can be broad or narrow, depending on what you might want to say in your image. I made this photo in the Bisti Badlands in New Mexico under sunny midday conditions. The stark white highlights, deep shadows, and deep gray background help communicate the harsh landscape by exploiting every possible tone.

Knowing that you perform contrast adjustments with ease in the digital darkroom can guide you in making exposure readings. If contrast is not too excessive, make your readings to include as much of the tonal range as possible. I photographed this scene with a digital camera with the exposure lock on the shadow areas and exposure compensation at -1. The result: a very good rendition of the shadow detail in the scene.

▶ Spectral highlights, like the glare off this pond, can produce flare, a ghosting that can cause unwanted effects in other parts of the image. One of the keys to controlling spectral highlights is to contain them within areas of darker tone. Darkening the image in the edit and manipulation stage helps, as does some extra burning and dodging around the highlight to keep it contained. Try to avoid composing with spectral highlights at the edges of your image, as they will be harder to separate from the paper white at the print borders.

COMPRESSED TONES

Brightness values in a scene can become muted even if you expose correctly. Usually, this problem results from flattening, or compressing, the potential tonal scale in scanning or printing. To use a musical metaphor, if you record a concert on a hand-held tape recorder hoping to re-create the sound of the full orchestra, you'll be disappointed when you play it back. The loss of fidelity in your recording may flatten the bass notes and mute the treble notes; flutes may become shrill, while the distinction between the bass fiddle and tuba may be lost and come out like a deep "blah" sound.

In visual terms, the highlights may all merge into a harsh white, and the shadow, or deep tonal separation, may lump into a dark mass. You may even compress the tonal scale so much that all the tones come out in a gray mass, with little or no distinction between them. Some loss is inevitable when you translate a recorded image to a print. You'll witness some loss in the mere recording of the scene—for instance, the brightness value range might exceed the recording capabilities of the film or sensor. In addition, all photographic media see somewhat differently than the eye does, and may indeed be blind to some tonal separations in the original scene. Visually, we see the image on the screen as being backlit and the image on the print as reflected light, which alone accounts for some of the loss. Technology, too, has an effect: In some cases we might record or scan at 16-bit and have to edit and print at 8-bit. But even with some of these built-in hindrances, you can learn how to work through or around limitations. Once you do, you'll begin to see how the fullest possible tonal scale can be recorded and eventually brought to play in the print.

When you get into the digital darkroom and make a print, you can enhance or correct tonal values in many ways. You can make selective areas within the scene lighter or darker, or increase or lessen contrast. Making selective areas darker, or bringing down values, is called burning; making certain areas lighter, or opening them up, is called dodging. The great many ways you can control, enhance, and even correct tonal variety is in large part the subject of this book.

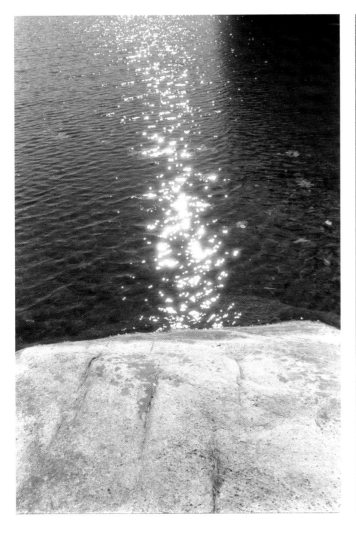 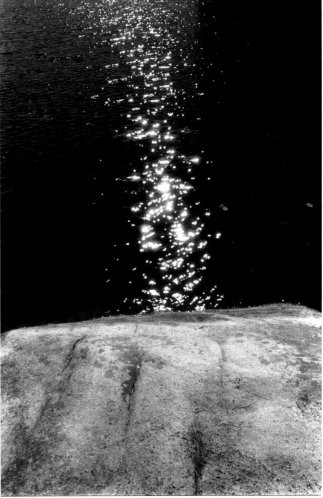

CONTRAST

Contrast is the visual play between the ambient light and the subjects in the scene.

Contrast is the relationship between light and dark tones in an image—that is, the relationship between the highlights and shadows. On bright days with deep black shadows we have fairly high contrast. On overcast days with no shadows we have low contrast.

Contrast is not just determined by the overall light value. The range of subjects and their reflectance within the scene has a profound effect on contrast as well. For example, if we have one bright, shiny object within an overall "flat" lighting situation, we may have a high-contrast situation, just as we may have low contrast on a bright day in a snowy field.

We measure the brightest and darkest parts of the scene with a light meter, and derive the contrast reading from the difference. The difference between the brightest and darkest parts of the scene is measured as Exposure Value, known simply as EV, a combination of aperture and shutter speed with which a photographer can measure contrast and adjust the settings to get the best possible picture.

Often, you can correct or enhance contrast in an image to add visual impact. There are many ways to manipulate contrast: You can take corrective steps to add tonality to a blank or overcast sky, make up for underexposure in a high-contrast scene, or tone down highlights that have scant texture or surface detail. To enhance contrast for creative purposes, you can change the relationship of dark-to-light values—you can add more contrast to enhance an abstract view of a city, for instance, or you can mute the contrast to enhance a bucolic nature scene.

In digital printing, as in silver printing, the main enemy is excessive contrast. This occurs when a loss of shadow detail and overly bright highlights create a harsh, textureless look. In silver printing you can, to an extent, control this by burning through the density and creating some tone on the print (even though you cannot retrieve lost highlight detail). In digital printing you do not fog highlights through exposure—you have to get some ink down on the paper to create density (a value below paper white) on the print.

A print can communicate the character of the ambient light, and even the time of day and temperature of the air! I photographed this abandoned shack in the desert in the middle of the summer, with the light shimmering all around. Emphasizing the brighter values communicates the feeling of the moment that the image was made. Notice that I took care to maintain texture in even the brightest highlight values, keeping them as significant highlights.

I made this photograph (left) with a red filter over the lens on 35mm black-and-white negative film. While this technique boosted contrast and deepened the blue sky, it resulted in excessive overall contrast and it took quite a bit of work to bring this harsh contrast under control. My advice is to avoid using such contrast filters on your camera (film or digital) and make desired contrast changes in the digital darkroom. Just about the only filter I keep in my camera bag these days is a polarizer. The image below resulted from lowering contrast using Selection tools and Levels controls.

Printing techniques allow you to manipulate values to enhance every subject and scene. Your primary job is to record as much of the tonal range as possible, and then consider selective contrast and density enhancements later. The scene at right seems fine as is, with a good range of light to dark tonal values. After I "brought down" (made darker) the background values, however, the trees and branches in the foreground pop more and the rendition is much more effective.

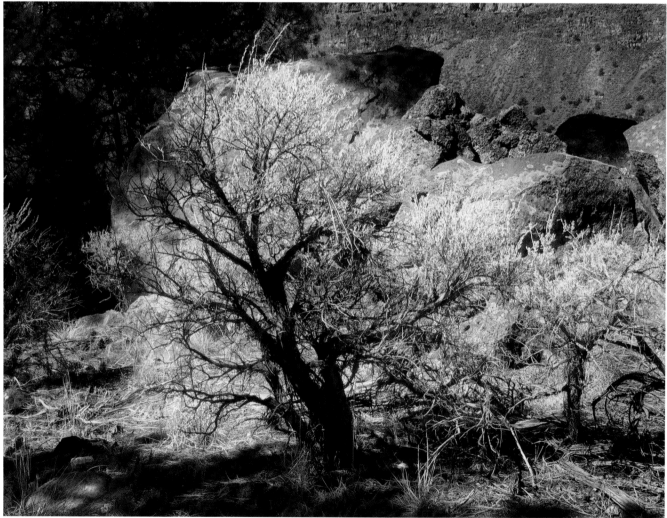

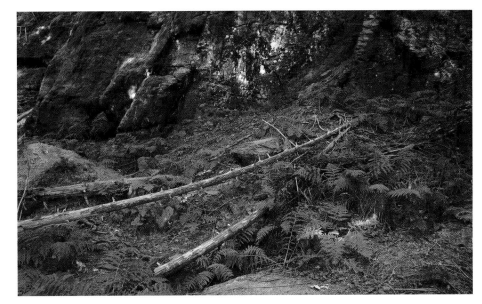

This scene was made in deep-forest light, resulting in a fairly flat, dark image (top). The first step in enhancing the scene was to "open up" the exposure by about a stop, easily done within the Raw image processor or through the use of Screen Blending mode (center). To increase contrast somewhat, I used the Burn tool in selective parts of the image (bottom). This created a more dynamic image with a full range of tonal values—how the subject was seen, not necessarily how it was first recorded. Printmaking is enhancing and interpreting photographs in ways that serve your creative visual instincts and desires.

Selective control of tonal values equals contrast adjustment. In this photograph I took in the Malpais area of central New Mexico, I made the darker values deeper to raise the perception of brightness in the lighter areas, which were untouched. Often, raising or lowering exposure of one value will change the overall feeling of the image. Simplicity in approach can make enhancement of an image an easy affair.

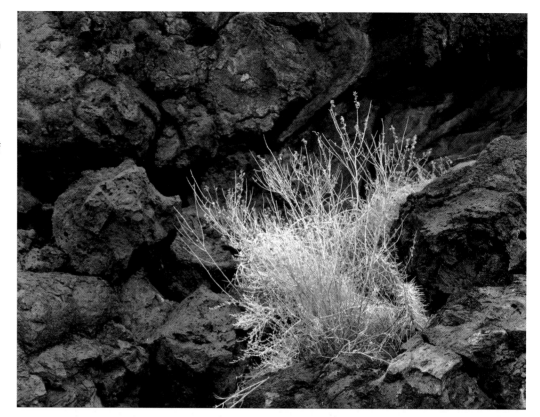

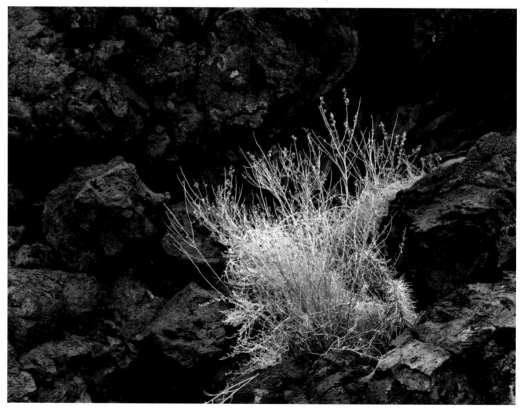

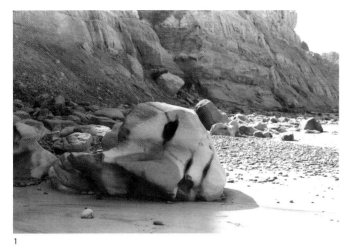

2

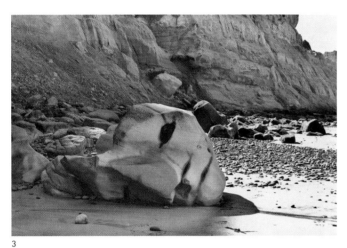

1

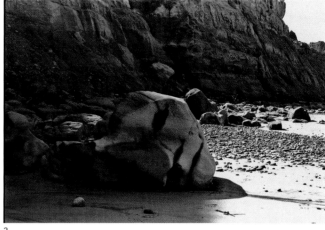

4

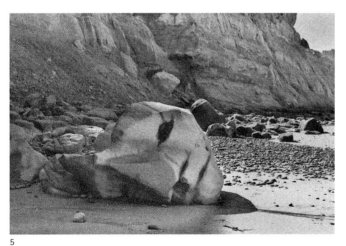

3

This photograph (**1**) was made from a scanned 35mm
negative. Because of the high contrast, I exposed for the
shadow detail and developed the negative for 20 percent
less than normal, but the highlights remained quite harsh.
After scanning, I darkened the entire image using an
Adjustment Layer with Multiply Blending mode, which
darkened the highlight areas without increasing overall
contrast (**2**). I then used a Layer Mask/Paintbrush tool to
"cut back" to the original shadow values, keeping the
highlights untouched (**3**). I added a touch more density to
the highlights with the Burn tool (Highlights/18% Exposure)
on a Duplicate Layer (**4**). I then added grain to the entire
image to help unify the values, using the Noise>Add Noise
filter (**5**).

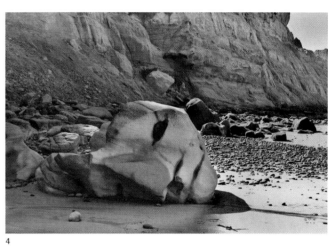

5

EXPOSURE

Shutter speed and aperture value determine the quantity of light in an image. Digital technology gives you an enormous amount of creativity in working with these values.

In digital camera recording, an address identified by binary code signifies the density in the image. Each pixel contains information about the relative brightness of the light, which in turn is read by the image-editing software. When you work digitally you are using software to read out a series of codes that emulate the density you see on the screen and subsequently the density of the ink on the print. In essence, you turn a virtual image into ink on paper.

When you work with film, during exposure the degree of change of silver halides is proportionate to the amount of light energy that strikes them. Thus, brighter light creates a greater change in silver halides, which, during the development process deposits more metallic silver on the film; dimmer light results in less change, thus fewer deposits. This deposit is referred to as density, and this den-sity translates into darker and lighter tones in the negative, which mirror, in reverse, the brighter and darker areas within the scene.

One of the major differences between film and digital photography is the way the image is read and how you use code rather than negative density to re-create brightness values on prints. Each pixel contains the exposure DNA, if you will (and in the relationship of those millions of pixel addresses, the scene contrast). As a result, you have an incredible amount of control over that image. In fact, you can alter the values of exposure and contrast in an almost pixel-by-pixel manner. You have the flexibility to make prints that emulate, as much as possible, the values in the original scene or to alter them in just about any way you desire.

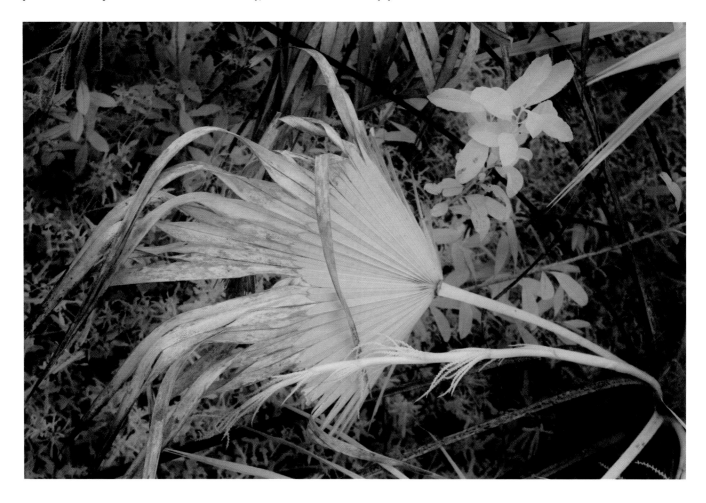

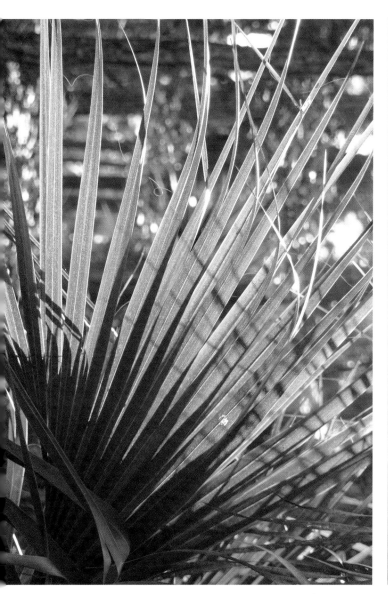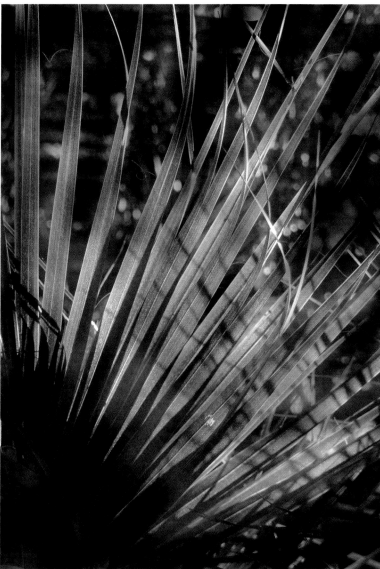

When photographing, a good rule of thumb is to "follow the light" and enhance that light when manipulating the image later. This palm frond was backlit, but I exposed to get as much shadow detail as possible. This gave me numerous options. I chose to go dark to enhance the backlit effect.

◄ This photograph was made using an infrared-adapted digital SLR. When printing, I didn't want to lose the infrared effect, which meant that the lighter values should remain ethereal. I "burned down" (made darker) the surrounding areas to enhance the lighter areas even more.

TONAL CONSISTENCY

A photographic print has a certain rhythm—a flow of tonality, exposure, and contrast that creates a cohesive image.

If you open the shadows but burn up highlights, you lose the flow of an image. If the direction of light is obvious but light from another unexplained source intrudes, the eye will reject the scenario. In addition to paying attention to this rhythm as it naturally occurs, you should also consider certain tricks of the printing trade that help augment the rhythm. Consider, for instance, the direction of light within and though a print. The story goes that the film director Eric von Stroheim always lit Marlene Dietrich brighter than any other person or part of the scene. Apparently, von Stroheim would have one lighting technician follow her throughout the scene, always throwing light on her face and form. This created a glow that became part of her screen legend.

The point is, you should pay attention to how light is handled within a scene and how you can exploit it to add subtle emphasis to your main subject. This becomes clear in portraiture, where you always want to make sure the subject's face is brighter than the surroundings. The brightness both focuses the eye and creates a dimensional feeling of space and volume. You can apply the same principle to scenics, close-ups, and abstract studies. Think

about the location of the light source, the character of the light, and how you can treat the surrounding area to add just a touch of emphasis to the subject you want to enhance and draw the viewer's eye into the picture.

That brings us to edge-burning, a tried-and-true printer's trick for bringing the eye to the "center" of the print. Edge-burning is a subtle technique in which you make the edges of the print slightly darker than the main subject in the scene. In digital photography, you will be using selection tools and Layer Masks to create this effect in just about any print.

Another trick is to create visual rhythm by carefully using Burn and Dodge controls in areas with monotonous blocks of tonal values. You can make these blocks more attractive to the eye and create a source of visual enjoyment. For example, say you have a field of ferns that is consistently lit and is in the foreground of a deep forest scene. You can burn down areas, emphasize shadows, and elevate highlights to make the field of ferns even more visually engaging. This technique is useful in scenes that include clouds and water, in which blocks of the same tonal values are likely to occur, and even in portraits.

This print is all about creating a center of light, though you shouldn't take the term too literally. While the original was somewhat brighter in the center than the rest of the scene, I darkened the edges considerably to add drama.

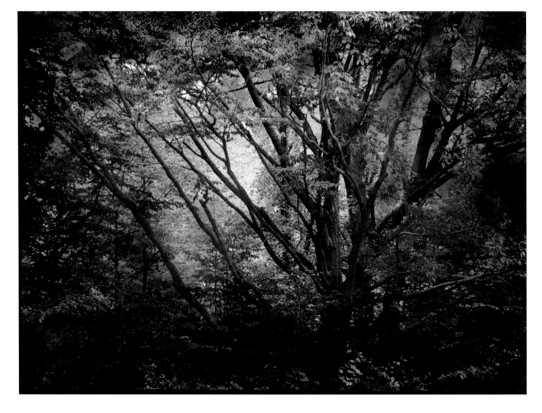

One of the ways to create more visual interest in a print is to break up large masses of similar tonal values. Here the field of grasses in the foreground creates a large block of fairly harsh value. To create some tonal variety I selectively burned the foreground (adding density) to unify the tonal consistency of the entire print and eliminate a large, distracting mass of harsh values.

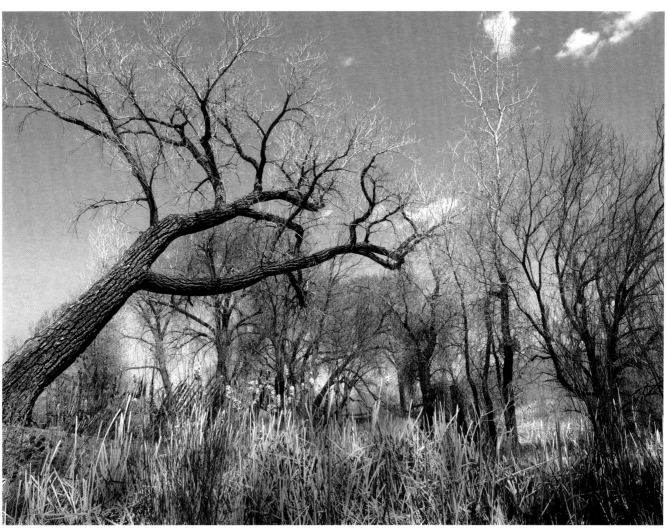

The color original was photographed in open shade, great for color but often a bit flat for black and white. After conversion I considered many different tonal variations and came up with edge burning, which added dimension to the main subject.

By selectively altering contrast and exposure in the scanned photograph on the left, I shifted emphasis from the overall scene to a particular element within the scene. Often, prints are about what is not revealed as much as what is, and it's part of the creative process to identify the picture within the picture. Photos like this are often sparks for your imagination. Because you can visualize the changes as you work, you can experiment in ways unimagined in the traditional darkroom.

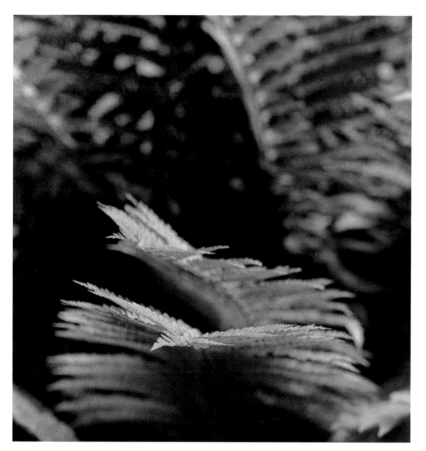

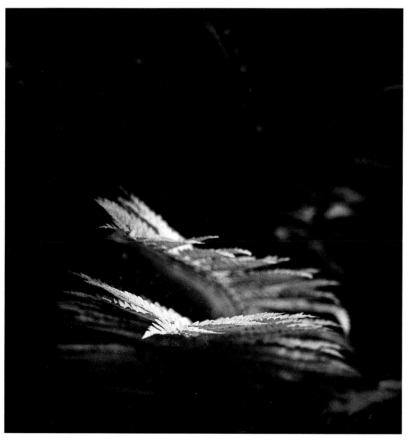

HIGHLIGHT CONTROL

With digital techniques, you can enhance and control highlights and inject "snap" into your prints in many ways.

The loss of texture in highlights renders any image harsh and unappealing. Proper exposure is the best way to avoid this; you should be especially watchful of overexposure with digital cameras. There are numerous ways to correct for this harshness, covered in Chapter Four.

Dull highlights (flat-looking bright areas) are equally unappealing, but fixing that is a much easier matter. Photographers who've worked with film in the darkroom might know about using potassium ferricyanide to clear highlights, or using selenium toner to snap prints up. Fortunately, digital printers help you achieve similar effects while avoiding these noxious chemicals.

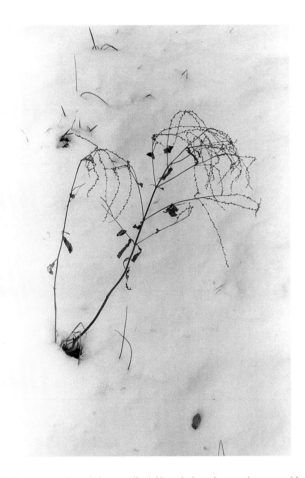 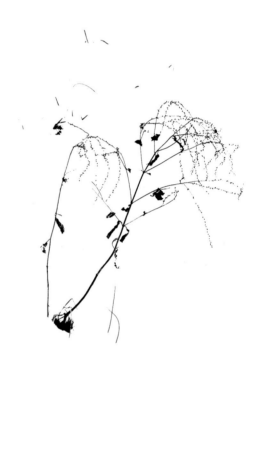

Contrast changes can be subtle or radical. Here, I altered a poorly exposed image of twigs in snow to represent a pen-and-ink drawing. With digital tools, you can make changes like this with ease.

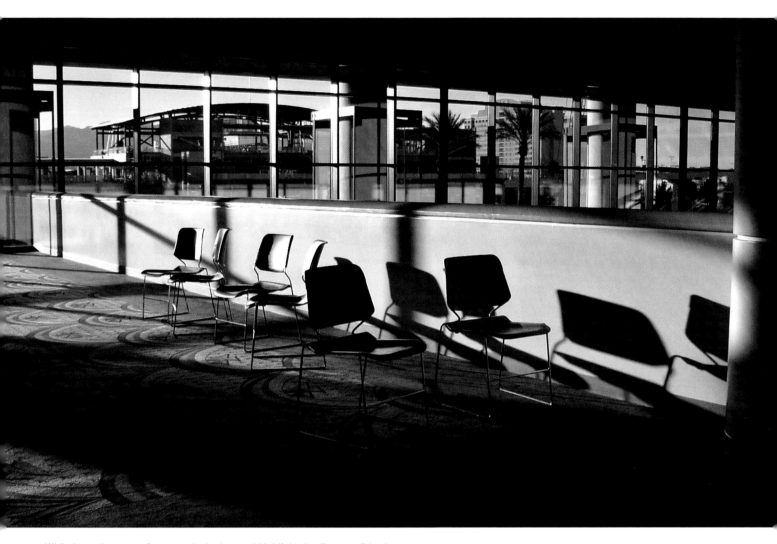

While I usually expose for as much shadow and highlight detail as possible, there are times when I see the final print in my head as I take the picture. That's the case here, where I exposed for the highlight values, thus driving the shadow details into deep tones. I knew I would never want the details in the chair shadows, so my exposure let them fall where they may. I then printed as exposed, with very little modification.

SHADOW DETAIL

Although a print with deep, dark values is certainly more acceptable than one with harsh highlights, at times you'll want to enhance deep shadow values or obtain detail, no matter how sparse, in the darker tones in a print. Having such values and detail can open a print up in ways that you might not have noticed before. As long as there is detail available in the pixel information, it's fairly easy to open up shadows.

In all, approaching a print in a fairly rigorous way and considering the factors I have outlined above will lead to a much more satisfying printing experience. It will also enhance the print so others can enjoy it to its fullest. While some people might not quite know why they prefer certain prints over others, it is usually because of the qualities I have outlined above. Fellow photographers—and especially printmakers—will understand what you have achieved and they'll give you a knowing, appreciative nod when they look at your work.

Throughout this book I'll refer to these print attributes and give you the tools to realize the fullest potential of every subject and scene. Once you have the tools in hand it's up to you to apply them as you wish.

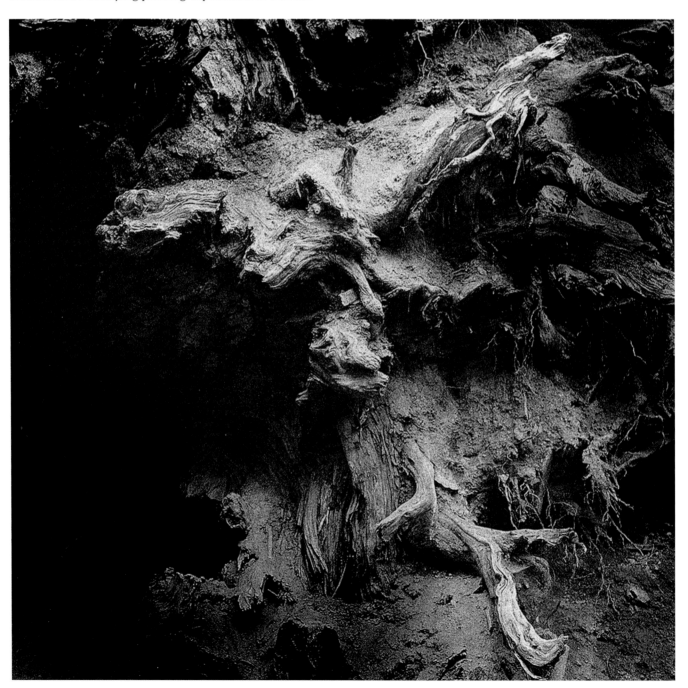

▲ The dynamic range of film can be quite impressive, especially when exposure and development is coordinated. Here a wide range of values is recorded by reading the shadow area and reducing exposure from that reading by two stops and development by 20 percent. To keep the shadows open (readable details and texture) and to subdue the highlights in this scan of the negative, I used a Levels Adjustment Layer with a Multiply Blending mode. After that I masked back the shadows to their original (scanned) values.

◄ Because you can alter each pixel address in a digital image, your ability to play with images is limited only by your imagination. In this exposure of the base of an uprooted tree, burn and dodge techniques caused new forms to emerge from the tangle of shapes and values.

THE RIGHT EQUIPMENT

Producing a black-and-white digital print begins with making the right decisions when getting an image into digital form. Then comes the challenge of successfully reproducing the image onto paper.

FILM AND DIGITAL SOURCES
FOR DIGITAL IMAGE FILES

An image must be in digital form so you can work on it. How you digitize the image doesn't matter. What does matter is that you pay attention to some of the unique challenges that digital photography presents.

The digital format requires that you perform specific tasks that might be new to you and that clearly differentiate digital from film. For example, both film and digital prints made for the gallery wall should be printed differently than they would be if used as illustrations in a newspaper. In addition, an image intended for use as a large print needs to be set up differently than it does when used for a web page or e-mail attachment. Making the right choices up front will make your task so much easier later. You will live and learn, but be aware that certain missteps will definitely impede your progress.

Here's an overview of some of those considerations.

- The first step is making an exposure in the camera—be it film or digital—that will faithfully render the brightness values in the original scene, and that will result in an image that is "easy" to print. While automatic-exposure cameras have made this considerably less of a challenge, there are certain lighting conditions and subjects that can cause problems. Reading the light in the scene, and making judgments about how that light best translates to film or digital sensor, is one of the most critical aspects of photography. While remedial steps can be made to correct exposure errors, a badly exposed image can cause major headaches in printing. The challenge is to balance the sensitivity of the recording medium with the light values and to do so in a way that yields an equivalent range of those light values on the film or on the sensor that sends that information through the image processor to the memory card.

- The second step is getting the image into digital form. If you photograph with a digital camera you've already accomplished this step. You need to be aware, however, that how you set up the camera—especially with the proper resolution and file format—is key to making the kind of prints you want. If you are working from film images—color or black-and-white negatives, slides, or prints—you'll need to digitize them by scanning them or having someone scan them for you.

- The final step is making prints, which involves creative decisions about how the light originally captured is to be rendered by ink onto paper. This brings into play matters such as proper monitor calibration, paper profiling, and using techniques to get a digitized image ready for continuous-tone printing.

A digital image is composed of pixels. These picture-building blocks each have a distinct address that includes information on brightness, contrast, and color. Your ability to change each address means you have incredible control over every aspect of the image. To visualize these pixels, open up an image and keep hitting the Zoom tool. At one point the illusion of continuous tone breaks down and the pixels are revealed. Here's a close look at pixels in a tonally rich image with increasing magnification.

DIGITAL CAMERAS

Digital cameras range from simple point-and-shoot models to high-resolution backs and SLRs. With the right techniques, you can optimize every picture you make with just about any digital camera.

SENSOR SIZE AND MEGAPIXELS

Obviously, if you already shoot with a digital camera you are ahead of the game when it comes to making digital prints. But I would like to insert a note of caution about digital cameras. While some can match and even exceed the quality of film cameras, not every digital camera will give you the high-quality prints you can get if you scan from well-exposed and properly focused film images. This is especially true if you photograph in film formats larger than 35mm.

One of the keys to getting good images to print is sensor size, defined as the megapixel count. The megapixel count of the sensor determines the size of the print that can be produced from the digital file. Mega means "millions" and refers to the number of photo sites—or light and image-gathering points—on the sensor. In general, if you would like to make good prints as large as 8x10 inches you will need at least a 4-megapixel camera. If you want to make larger prints—or get the best quality in your 8x10 inch prints—then a camera with a mexapixel count of 5, 6, or greater is recommended. Of course, megapixels are not the only components of image quality. The lens and the camera's image processor have an effect, too; indeed, I've worked with 4- and 5-megapixel cameras that don't provide the quality of a single-use film camera.

The size of image file your camera can produce determines the size of the print you can make from it. For example, an 8x10 inch print will require, at a minimum, a 10–12 MB image file. To find out how "large" your image files can be from your digital camera, simply multiply the megapixel count by 3. This assumes that you are photographing with the largest pixel resolution your camera's sensor can deliver. If you want larger file sizes—which you might for making 13x19 inch prints or larger—then you will need to use a digital camera with as high a megapixel count as you can get.

FILE SIZE AND PRINT SIZE

While each image has a certain resolution leeway, there are ballpark figures that allow you to predict fairly well how file size can affect print quality. You can get a decent 8x10 inch print from a 3-megapixel camera, but you are usually better off with a 4- to 5-megapixel camera. For sizes up to 5x7 inches, a 2- to 3-megapixel camera will do fine, albeit with some loss of sharpness and tonal separation. I use the figures shown here when I select an image size, when I make my own film scans, or when I set up my digital camera. Note that you can use smaller file sizes in some instances and even resample up the size a bit for bigger prints. In other words, there's what you could call a "fudge factor" in all this. Note also that I give these figures for 8-bit images.

Print Size (inches)	File Size RGB (or file size you input when scanning)	Megapixel Count of Camera
16x20 and up	72 MB and up	24 MP
11x14 to 16x20 and up	42 MB and up	14 MP and up
8x10 to 11x14 and up	18 MB and up	6 MP
5x7 to 8x10 and up	12 MB and up	4 MP

One of the key components of image quality is the resolution setting on your digital camera or scanner. Quality begins to deteriorate the further away you get from the resolution/enlargement "safety zone." This photograph was scanned at three different resolutions—one at 300 dpi, one at 150 dpi, and one at 72 dpi, then enlarged to 8x8 inches. Note how the quality, sharpness, and detail deteriorate as the dpi gets lower. You get a similar effect if you shoot at too low a resolution in your digital camera or fail to change the resolution setting in the Image Size dialog box in your image-editing software.

FILE FORMATS AND RESOLUTION
WHEN USING YOUR DIGITAL CAMERA

You have a number of options when making photographs with your digital camera. Here are some guidelines that will help ensure that you get the best possible images.

• If you have a digital camera that only allows you to photograph in JPEG format, choose the largest file size you can get. If you have a choice of various pixel resolutions, choose the largest as well. For example, if the choice is between 640x480, 1280x960, or 2560x1920, choose 2560x1920. This will ensure that you capture all the information the sensor is able to record. Also, choose the lowest compression ratio. If, for example, you have a choice between Super Fine, Fine, and Normal, or some such naming scheme, choose Super Fine. Compression

is a way for the system to gather more images on a given capacity memory card, but it tosses away information when it writes to the card and replaces that information with mathematical formulas, not raw image data. Don't tweak the image in the camera with contrast or sharpness settings. These are fine for special effects in the camera, but you can do a better job later when working with software in the digital darkroom. Finally, don't use digital zoom. This actually crops into the sensor area, reducing the resolution and the resultant image file size. My advice is to walk closer, get a longer-range zoom if necessary, or crop later in the computer.

• If you have a camera that allows you to choose between JPEG and TIFF format, choose TIFF and also choose the highest possible resolution in TIFF format. This will eat

The largest print I can get from this image, which I made with a 3-megapixel digital camera, is a 5x7, and even that's pushing it a bit. When photographing with a digital camera, keep your expectations in line with the resolution at which you make the image. Some image-processing programs do a good job of resampling, or manufacturing image information, but this rarely matches the original data. Too much resampling deteriorates image quality.

You can convert from color to black and white from digital-camera files and scans in any number of ways. An easy way is to go to the Image>Adjust>Channel Mixer in Photoshop and check the Monochrome box. The channel sliders allow you to customize the conversion to taste.

Raw is becoming the digital-camera format of choice because of its customization features, but it does require more work on your part. In effect, you defer image processing from the camera to the computer. Raw is superior to JPEG because it maintains all data, and to TIFF because it takes up less data space on your memory card and hard drive. The screen shot above shows a series of Raw images in the Canon software browser. The other screen shot shows an early version of the Raw Utility with the exposure compensation feature activated. I advise using Raw for photographs that you might want to enlarge beyond snapshot size later.

up more space on your memory card, but the TIFF format does not toss out image information (compress the image) when it records on the card. Get larger-capacity memory cards or have extra cards ready when you go out to photograph. If memory runs low in the middle of a shooting session, switch to JPEG.

- If you have a camera that allows you to choose between JPEG, TIFF, and Raw format, choose Raw. Raw files take up to 40- to 50-percent less memory than TIFF files do, and the Raw format is subject to less image processing in the camera. You can use 8-bit or 16-bit depth, as opposed to just 8-bit depth captured by using other file formats in most digital cameras. This simply means more information is captured—in terms of tonality, contrast, and color richness. The only drawback to Raw is that you have to use special software to work with the files, though Adobe and other companies are now providing more options for working with Raw files. Be aware, however, that when working with Raw files you should have a lot of RAM and a fairly powerful computer system to fully enjoy these expanded ranges. If you have a choice of pixel resolutions in Raw, choose the highest pixel count. If you have a choice between 8-bit and 16-bit recording, choose the higher bit depth. Be aware, however, that higher bit capture eats up considerably more space on your memory card and in your computer.

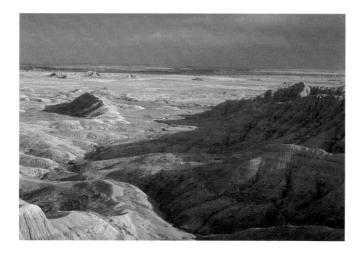 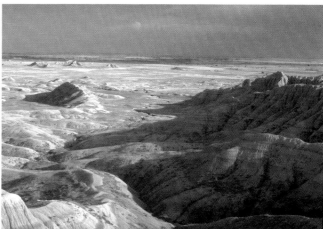

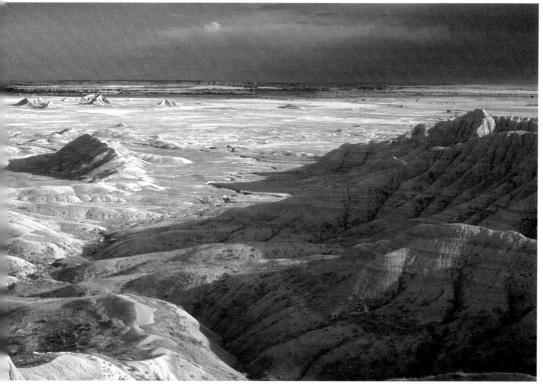

You can make prints from just about any image, including those you probably wouldn't have otherwise shared with the world. I made this color slide in 1975 on Kodachrome film. I scanned it more than a quarter of a century later, converted the image to black and white, and did some quick editing work to fix image flaws (dust and scratches) and enhance contrast and tonal flow.

SCANNERS

If you've ever shot film, a scanner is an almost essential piece of equipment in your digital darkroom. You'll probably be astonished at the quality of detail a scan can deliver.

Flatbed scanners, used to scan prints and film, look and work like office copy machines. Once the lid is closed a CCD array passes across the surface and digitizes line by line. You can use a flatbed scanner for more than paper prints. I have used mine to scan glass negatives, tintypes, daguerreotypes, and albumen images mounted on cardboard. More expensive flatbed scanners come with film adapters to use for scanning negatives and slides. You can also use a dedicated film scanner for this purpose, but I find that a high-quality flatbed scanner with a film adapter is quite adequate for scanning negatives and slides.

Most scanners offer a choice of working in either grayscale or RGB (color) mode. I scan all my black-and-white images in RGB, then convert to black and white using the Channel Mixer, a software tool that we'll make good use of in the chapters ahead. Or, I simply go to Image>Desaturate to make the conversion. Some new scanners, though, do an excellent job with grayscale images. Test your scanner to see which mode works best for you. Keep in mind, too, that if you are working in grayscale your image file will be one-third the size of the same file in RGB. This does not affect overall resolution or quality. Be aware that some scanners do a better job in

RGB and fall down in the grayscale mode, and some don't offer grayscale mode at all. Check the specs before you buy.

SCANNER SOFTWARE AND IMAGE ADJUSTMENTS

I am usually amazed at the detail my scanners deliver, especially when I compare the image on the screen to a print I may have made previously in the darkroom. A number of other printmakers have reported the same amazement. The scanner seems to "dig" into the film to reveal detail and rich tonality that you might only see when viewing the film on a light box through a high-powered loupe.

If a print or negative from which you are making a scan is problematic—is underexposed or scratched, for instance, or some highlights are burned up or areas are faded—you can use software that comes with the scanner to fix some of the problems before you import the image to your computer and your image-editing software. Whether you make major adjustments in the scanner, and how much adjustment you should make, is a matter of debate. I try to strike a balance and make some minor adjustments in the scanner software and the rest in the imaging software.

A scanner is an essential tool in the digital darkroom. Flatbed scanners are especially handy, because they allow you to revive old prints from the family album or make copies of photographic materials that might be difficult to manipulate even in a traditional darkroom. I placed this glass-plate negative from around 1890 on a flatbed scanner and backed it with an opaque, smooth sheet of white printing paper to get a scan that allowed me to make an excellent 11x14 print.

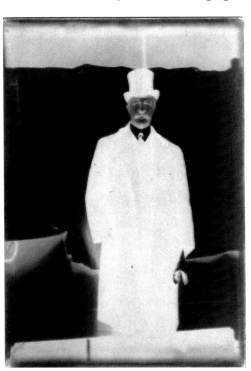

WHICH YIELDS THE BEST PRINTS:
SCANNED FILM OR QUALITY DIGITAL CAMERA CAPTURE?

As more affordable digital cameras offer higher resolution, the debate about which yields the best results for prints continues. In my first book on this subject, done about seven years ago, I decidedly came down on the side of scanned film. In this book, and in my printing today, I am much less certain of that stance. I still continue to mine my film archives for printing, which accounts for much of my scanning work today. And I still shoot film. But more and more I'm finding that I choose to print with images captured directly from a digital camera.

Of course, there's more to image quality than just its megapixel count, just as film quality results from proper exposure, development, choice of lens, etc. Indeed, both mediums rely on the skill of the photographer and how he or she nuances light and exposure, as well as the point of view when the picture is made.

If you want to work from film but don't want to or can't invest in a good scanner, there are plenty of labs that can perform the scans for you. But just as with film labs, scanning labs range from good to bad. My advice is to test a scanning facility with a range of film types and exposures and make sure that the service does a good job before you commit a large body of work to it.

Whether you work directly from a digital camera or scan from film or prints, you'll get the best results when you get as much visual information—tones and details—as you can in the image file. You can make the image lighter or darker or increase contrast later. This picture was printed without any interpretation and matches closely the original tonal values in the scene. Properly scanned or exposed digital image files will make your work much easier.

To a certain extent, you can adjust for exposure mistakes when scanning, or do it later with the techniques we cover in Chapter Four. Here's a simple example. The simulated negative above is clearly underexposed. If a print were made without correction, you'd get the result shown at the top of the opposite page. The Histogram, right, tells the tale. Even though the shadow areas are clipped, the main loss is in the highlight areas. A simple shift of the white point (the triangle at the right side of the graph) results in a better rendition. It raises contrast without further loss of shadow detail. The ability to raise one part of the contrast scale (the highlights) without simultaneously doing the same to the shadow areas differentiates this approach from working with a higher-contrast grade in the darkroom.

SCANNER NUMBERS

Resolution refers to the number of pixels per inch (ppi) in an image. More pixels mean more image information and the ability to make a larger print that will show detail and subtle tonal information—that is, to have better resolution (see page 58). Resolution is a relational number in that it exists in conjunction with a certain image size. A 1-inch by 1-inch image at a resolution of 80 ppi (pixels per inch) has 6400 (80 times 80) pixels. The same image at 200 ppi has 40,000 (200 times 200) pixels.

Your scanner might allow you to scan in 8-bit, 16-bit, or other bit-depth modes. As I've mentioned, using a higher bit mode yields more image information but requires a much larger file size. Some software programs (such as the recent versions of Photoshop) provide many more editing options when working with 16-bit files. If you have the processing power and can work on these 16-bit files in your software program, consider scanning in the higher bit mode. Even if you have to compress the image information later you'll have more image information with which to work.

Just as you choose a certain setup for making images in your digital camera, you have to "tell" the scanner what resolution you want it to scan the film or print. Today's scanner software makes choosing resolution easy and will usually determine resolution for you after prompting you to provide information about what you want to do with the image, at least in terms of print size (or "output," as the computer world calls it). You might also be asked about the type of material you are scanning. My scanner has "profiles" built in for many different types of film emulsions. This can be maddening, because I don't always know which version of a certain chrome or negative film I am working with, since there may have been variations in film stock that can change results. I try to find the most generic profile. Learning to input the correct information is all part of the trial and error of working with this equipment. (If you do not receive these prompts you are probably working in the "Auto," or default, mode; always switch to the Custom or Advanced mode and scan using the settings you input.)

SCANNER OPTIONS

Here are some of the standard choices you might have to make when scanning.

Desired output, file size, or resolution: Output just means the image file size. Follow the chart on page 58 for making prints of a certain size. In most cases you can type in the desired file size and the scanner will do the rest of the calculations for you. Note the "optical resolution" of the scanner—that's the largest size at which you should work. If you see a figure that has "interpolated resolution" or "resampled resolution," try to avoid it. Knowing the optical resolution of a scanner, and the file sizes it can create from the film you work with, should be an important part of your purchasing decision. If you want to make 11x14 inch prints, for example, make sure that the scanner can get you at least a 36 MB file from your film.

Image size or percentage: If you scan in a 35mm slide at 100 percent you will get a 1x1.5-inch size scan, the size of the frame. To make a scan for an 8x10 print you have to increase the size of the scan to greater than a 100-percent reproduction. In most cases you will be prompted to input the size of the print you want to make and the scanner will calculate the percentage you need for the scan.

Output dpi: Dpi means dots per inch, and refers to the printer resolution. If you are working with an inkjet printer a very safe bet is 300 dpi, although an input of 240 dpi can often work just as well. For example, when I get queries about how to submit electronic image files for publication in a magazine, I use 8x10 at 300 dpi as a standard.

WHEN TO CHANGE THE SCAN SETTINGS

If you are getting poor scans, you will want to change the default (factory-supplied) settings on the scanner. Most likely, you'll want to adjust the tone curve. Practice first, and see how your preview image in the scan changes as you move the tone curve around, then how it translates to a print.

You might have some problems with very thin film (underexposed and/or underdeveloped) or very thick film (overexposed and/or overdeveloped). Thin films often require an increase in contrast, but this often causes blocking of shadow detail and harsh highlights. You can tweak the contrast in the scanner software if you wish, but don't overdo it—you can make a much better fix in image-editing software. It's better to have a "flat" scan when working in your image-editing program than one that's been overcorrected in the scanner software. If your scanner and software allow multi-sampling—making two scans or more of the same image—you can correct this better than from a single scan.

Just as in the chemical darkroom, the negatives most likely to give printers fits are those that are overly dense. Not only do they tend to have excess grain, but they also can scan "gray," or deliver poor separation between the tonal values. Some scanners get a "kickback" of sorts from this type of negative and don't even get close to delivering the proper values. The best bet is to underscan, or move the tone curve to get a thinner, flatter scan and wait to correct the problem in image-editing software.

Some scanners have proprietary software for removing or diminishing excessive grain in a negative or slide. Some also have software for getting rid of scratches and other flaws during the scanning process. Test these with your images and see if they work for you. The flaw-removal software can save lots of retouching time later. Be aware, though, that implementing these programs will considerably extend the time it takes to make a scan.

In summary, I prefer a flat, or neutral, scan to one that's overly corrected. This produces an image that is quite malleable in the digital darkroom, where there are infinite controls for exposure and contrast.

IMAGE SOURCES FOR BLACK-AND-WHITE PRINTING

You might think that black-and-white negatives and slides are the preferred sources for black-and-white printing. Remember, once you digitize an image you can do just about anything with it, so the distinction you used to make (choosing only black-and-white film for black-and-white prints) is no longer necessary. Any image can be used as a source for black-and-white printing. You can use black-and-white or color prints, black-and-white slides and negatives, and color slides and negatives. Converting color to black and white is simply a matter of following prompts. You can use Image>Mode>Grayscale, Image>Mode>Grayscale>Duotone, Image>Adjust>Desaturate, Image>Adjust>Hue/Saturation and move the slider to 0, or Image>Channel Mixer. My advice is to scan black-and-white film and prints in RGB mode, then convert to monochrome later. Your experiences and experimentation may cause you to do otherwise, and some scanners perform better in Grayscale mode than they do in RGB for black-and-white materials.

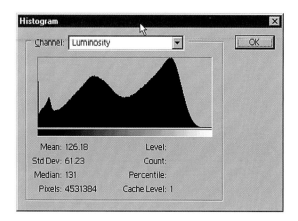

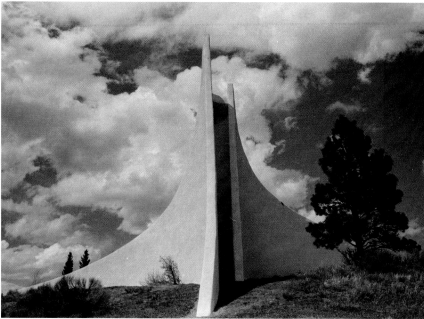

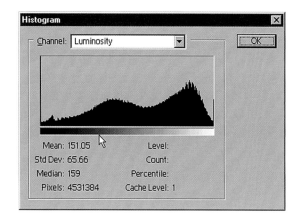

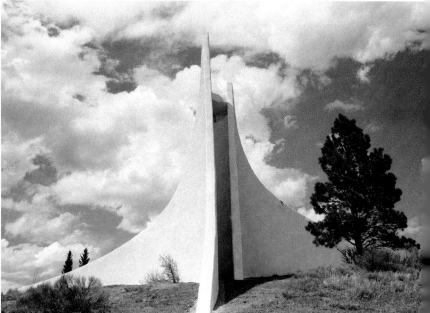

These scans were made from negatives exposed one stop apart, with the top image file and Histogram showing the result of one stop underexposure. Note how the highlight values fall off as they approach the white point. The bottom file shows a well-exposed negative/scan. Many digital cameras now have a built-in Histogram that allows you to review the exposure after the fact; some even have Histogram previews that you can use as a built-in exposure guide.

CHOOSING IMAGES FOR WORK

By making prints from well-exposed images, you'll leave yourself more time to enjoy your creativity.

I am a great believer in making life as easy as possible, and this applies to choosing photos for printing. My philosophy is that time spent correcting a poor image leaves less time for creative thought and applications. So, whenever possible, I choose well-exposed images to make prints.

The most troublesome types of images with which to work are those that have very high contrast, those that are overexposed, and those with any problems caused by flare or fogging. Guess what? Negatives, prints, and slides with these problems are just as troublesome to work with in the conventional darkroom. Although in many cases you can fix problems more easily in the digital darkroom, software is not a cure-all.

I have heard many photographers voice a new casualness about exposure and technical matters by saying, "I'm not worried—I'll fix it in Photoshop." Yes, in the digital darkroom you can fix problems that would be very difficult to handle in the conventional darkroom. Too often these folks have learned the hard way and have spent so much time trying to fix those images that they soon change their ways. These programs are pretty amazing, but working from poorly exposed images means you have a lot of work to do just to get them close to being acceptable. The point is, just because you're now in the digital world doesn't mean you are exempt from making good exposures and choosing good images to print.

DIGITAL IMAGING SOFTWARE

Visit a computer-supply store or surf the web and you'll notice dozens of versions of digital imaging software. Which is the best to use? My choice has been Photoshop (the full version) and, for quick fixes, the more affordably priced Photoshop Elements. But you might have gotten different software with your digital camera or have been attracted to other programs. In truth, most programs can do lots of magical tricks for you. I strongly suggest that you choose a program that offers Curves and Levels controls, a sophisticated color converter, Layers, Adjustment Layers, Blending Modes, and the ability to work with Layer Masks, or the equivalent (see Chapter Four for more on these features).

Another type of software you might want to explore is called a Plugin. This software works in conjunction with most popular image-manipulation programs and offers one-touch special effects and solutions for reducing grain, increasing sharpness, and placing graduated density filters in your image. While most Plugins are created for color work, an increasing number are dedicated solely to black and white.

If you are still shooting film, make exposure and development tests to see which images scan and print well. Experiment with different exposure techniques and developing times. The negative on the right is underexposed and somewhat underdeveloped—note the lack of detail in the piles and the high contrast between the shadow areas and highlights. This should be a tipoff that the negative will be difficult to print, and it is. Just a 1.5 stop increase and a 10-percent increase in developing time yields a much better negative (opposite page). The shadow detail in the piles is the telling difference: Note how much more detail is present in the positive. Printmaking will always make you a better photographer, and being a better photographer always makes for easier print-making, and better results.

THE BASIC TOOLS

Easy-to-use software tools give you a great amount of control over every aspect of an image—especially tonality, contrast, and sharpness. Master these tools, and they will help ensure that you produce great prints.

DIAGNOSTIC TOOLS

Two diagnostic tools are especially useful when working with exposure and contrast. The grayscale step wedge helps you calibrate your monitor to make sure that you are seeing all the potential values in an image on your screen. The histogram is a graphic representation of tonal values in your image and indicates where to make adjustments.

THE STEP WEDGE

Starting out with a well-calibrated monitor is essential. In fact, perhaps the most frustrating part of digital printing is failing to match the monitor image with what shows up on the print. Bringing input (the monitor image) and output (the print) as closely together as possible will reap great rewards and save you lots of time and frustration.

You can make some of the necessary monitor adjustments using Adobe Gamma (usually in the Controls panel on a PC) or ColorSync (for Mac users). You can also use special software and hardware to make calibrations, a more sophisticated solution that provides finer tuning and is worth considering as you become more involved in printmaking. Once you've calibrated the monitor, a step wedge allows you to check monitor contrast easily.

A step wedge is simply a visual representation of tonal values and shows how they might be rendered on the print. Tonal values in your prints will range between two extremes in the grayscale—paper white and ink black. Paper white is just that—the tone of the paper you use. Ink black is what you would get if you took a brush, dipped it into the ink cartridge, and painted the ink onto the print. The other gray values make up the remainder of the intermediate scale. You can make a step wedge showing up to 256 levels of gray, or simplify it into larger groups. One that breaks tonal values into 21 groups adequately shows what's going on with your printer and monitor.

Another important function of the step wedge is to check whether your gray values have a color cast or a color shift in different levels of gray. If they do, there's a chance that you will get split color on different gray values in the print, a very bothersome problem. If your scan or image is in RGB mode, go to Image>Mode>Grayscale. A prompt will ask you to decide whether or not you want to throw out the color information in the image. By clicking OK you should help correct the color shift.

YOUR DIGITAL TOOLBOX

The tools I discuss here have to do with exposure (tonality), contrast, and sharpness. Many other tools are available to you as well, but this is not a book about everything you can do in the digital darkroom. My approach is fairly simplified, and I tend to use tools over and over again. The tools I cover will allow you to accomplish just about every task you need to produce high-quality digital black-and-white prints.

My reference in this book is Adobe Photoshop, version 6 and above, though you may have some of these tools or all of them in other imaging programs you might use. In some cases the tools you have at your disposal may be similar to those I mention here but have different names—you should be able to recognize them through their function. Don't be too concerned if you do not have every tool I mention, as there are many ways to arrive at an image solution. Indeed, even the methods discussed here have many variants, and the way I arrive at a technique might be different from the one you end up using.

1

To create a step wedge, create a new document at 100 dpi, 8x10, RGB. This yields a blank canvas, if you will. Use a rectangular marquee (selection tool) set at 0 feathering to draw a rectangular selection on the screen. Next choose the gradient tool and set it to default, or black to white. Draw a straight line between the long ends of the box, making sure to start right at one edge and end at the opposite edge. (To keep the line straight use the Shift key as you draw.) Release the mouse when you reach the end of the line. You should now have a black-to-white gradient in the box you've created (**1**). Then go to Image>Adjust>Posterize (**2**) and type "21" in the dialog box. This breaks the grayscale spectrum into 21 steps, from deep black to "open" white (**3**). To see the effect contrast changes have on the tonal flow, go to Image>Adjust>Levels and drag the black-and-white points in toward the center. The result shown here (**4**) comes from this step. This compression of tones is the same that will occur on your images when you adjust contrast with these settings.

2

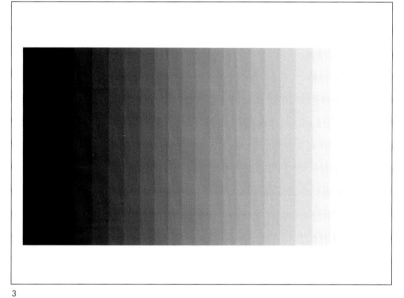

3

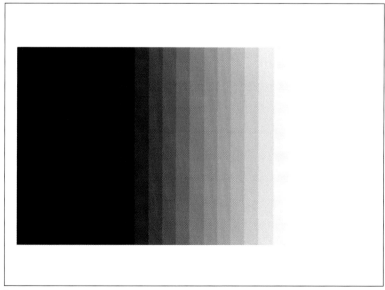

4

THE HISTOGRAM

The histogram is a graphic representation of the range of brightness values in your image. It is a visual map of tonal spread and allows you to judge how well you have exposed the image. A histogram is a true shortcut, at times, to image correction, especially for contrast control. When you open an image in Photoshop, take a look at the histogram. (Go to Image>Histogram on a PC or Image>Adjustment>Levels on a Mac.) Notice how the values are spread across the grayscale spectrum. Each image is unique, with its own spread of values—there is no good or bad histogram per se. A histogram in which values do not flow from end to end does not necessarily indicate a "bad" image—it's just that the tonal values in that image may be very light, dark, or absent in some areas.

A quick way to adjust the tonal spread in an image is to open up the Levels slider control and move the black-and-white points in the Levels dialog box to where they just "touch" the edges of the histogram readout. This spreads the values out to encompass the tonal spread.

This painting on the Berlin Wall (right) shows a good spread of values. A slight shifting of the black point toward the center would make the image even richer. The highlights on this building (opposite, top left) are slightly clipped, but the tonal and textural values are certainly redeemable. The church interior (opposite, top right) is underexposed, as seen in the clipping and "crowding" of the shadow values. (Note the highlight "blip" created by the light in the window.) See page 80 for a quick fix on this underexposure.

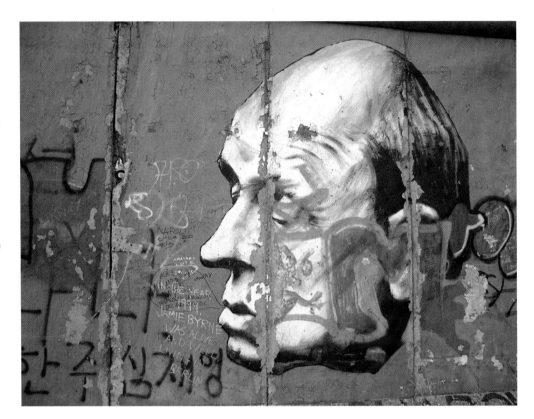

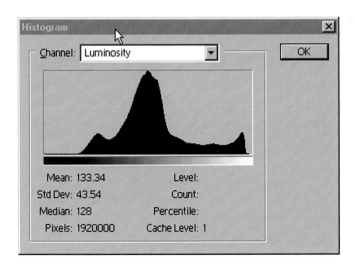

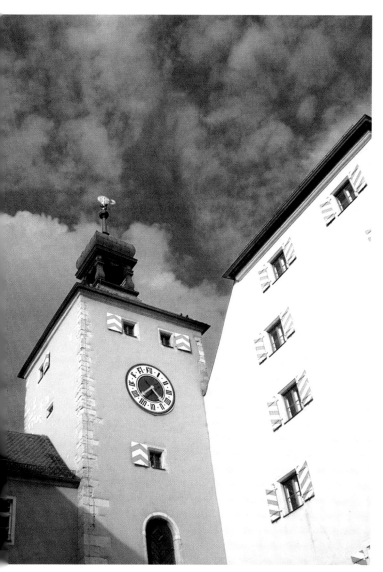

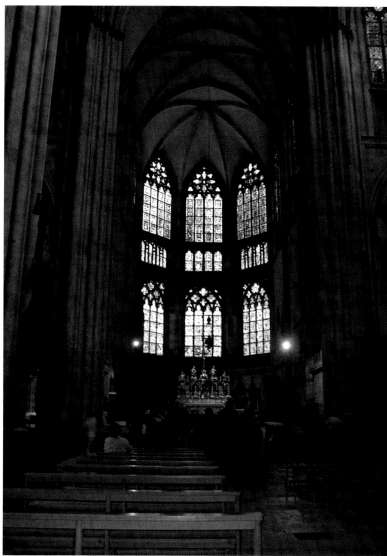

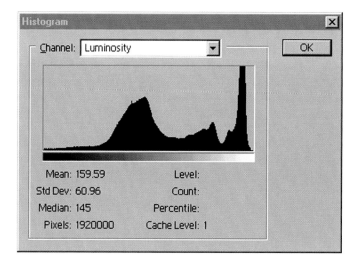

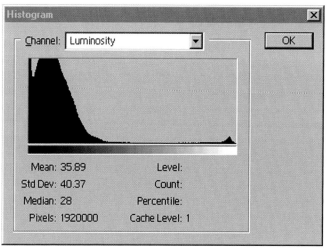

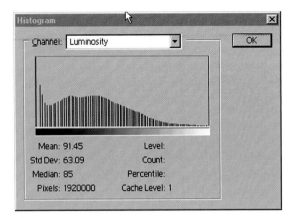

Histogram

Channel: Luminosity OK

Mean: 91.45 Level:
Std Dev: 63.09 Count:
Median: 85 Percentile:
Pixels: 1920000 Cache Level: 1

By going to Layer>New Adjustment Layer>Levels, you can fill the gamut of the histogram, an easy way to fix flat images (those with little or no contrast) or those that have been poorly exposed or scanned. Filling the gamut simply means moving the Black and White sliders close to where the histogram information begins. You can tweak the image further by working with the Middle Gray slider. In a Levels adjusted image (above), the interior reveals many more details and the resultant histogram shows more of a spread throughout the tonal gamut. A somewhat flat image (opposite page) is brightened by making a Levels adjustment. A field of sunflowers (page 82) shows a fairly good tonal range, but the histogram reveals some space on the highlight side. By moving the White Point slider to the left, the greater tonal potential of the image is revealed.

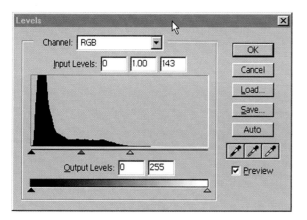

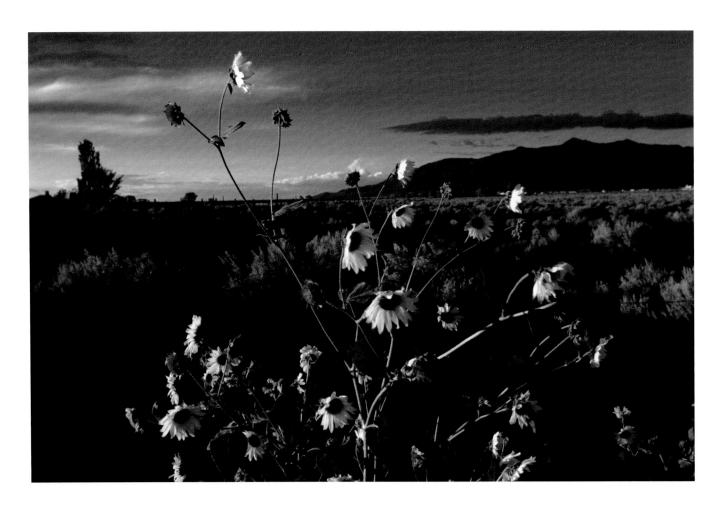

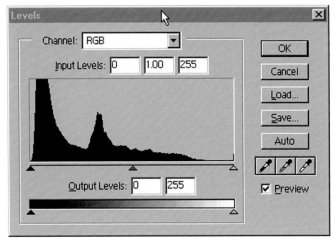

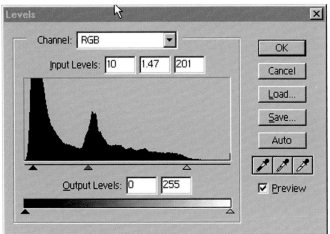

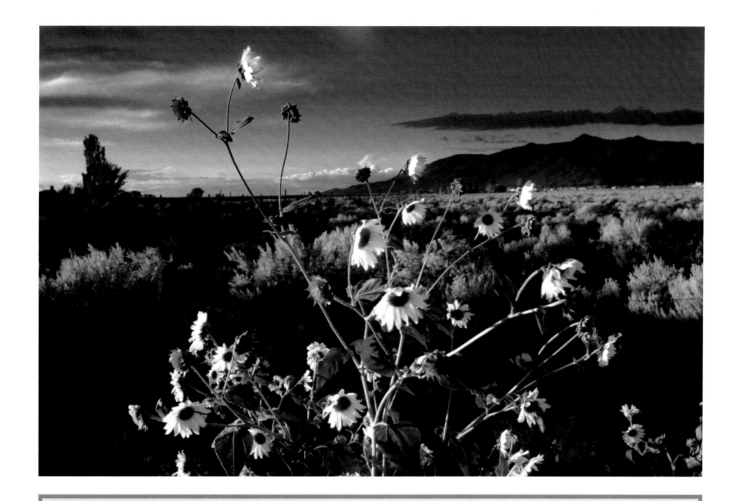

SETUP OPTIONS

When you first load Photoshop you should make some quick adjustments that will help ensure that the prints you make match the images you see on the screen. If you fail to follow these simple steps, your experience will be much more frustrating than it should be.

- Open the Color Settings dialog box and go to Edit>Color Settings. Choose US Prepress—not US Web or another setting. For Working Space, choose Adobe RGB. Also check the boxes about preserving the working space of the image you load. Work in the color space in which you scanned or photographed.

- Do a Save As and make a copy of your original. This keeps the file safe and allows you to feel freer about exploring all the possibilities in your work. This is unnecessary when working with Raw file formats, as you will save the Raw conversion as a TIFF when you bring it into your editing software.

- Go to View>Proof Setup>Custom and select the paper and printer with which you will be working. The choices should include any standard materials, assuming you have loaded the print drivers that came along with your printer. If they don't, you will have to locate or create a profile and place it under the Custom profiles area (see page 154). When you make your selections, you will be given a choice of working in Perceptual or Relative Colormetric. Perceptual is in general more saturated, and is usually associated with color printing, while Relative Colormetric works better with black and white. This does not mean you should always choose one over the other for each image you print; experiment with both to see which suits the image at hand. And finally, click on Black Point, as this will give you richer shadow values.

ADJUSTMENT LAYERS AND BLENDING MODES

With these indispensable tools, you can alter contrast, change exposure, work on selective tonal control, and do much, much more.

Adjustment Layers are, in effect, a collection of filters, each of which can affect nearly every pixel in an image. In addition, each of these filters has what you could call an "effect rheostat" that allows you to dim, or turn down, any effect to the nth degree. You can apply these filters globally (across the entire image) or to select parts of the image. Think about Layers in terms of a tall box with numerous slots. You slide your image into a slot at the base of the box. Then you slide various filters in and out of the other slots, while watching from the top of the box to see the effects these filters are having on the image.

You can use as many Adjustment Layers as you wish, but to keep some sense of order try to limit yourself to a reasonable number (maximum five) as you begin. When you become more familiar with Layers, you can, of course, use as many as you deem necessary. But using too

When you work with Layers you can also apply Blending Modes, available either in the Levels dialog box of a New Adjustment Layer or via the Layers palette. I use Blending Modes as exposure controls. In this scene an auto-exposure setting was fooled by the bright, reflective white and rendered it toward a middle gray, as it is calibrated to do. I corrected this easily by applying a Screen Blending Mode in the Layer>New Adjustment Layer>Levels step.

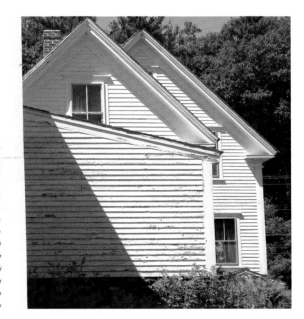

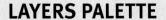

LAYERS PALETTE

The Layers palette shows the background, or original image, and the Layers, Adjustment Layers, Blending Modes, and masks you may have applied. Once you have created a Layer you can use the palette to modify it with the Opacity slider. Grab the arrow under the slider and move it left, away from 100 percent, and you'll see the effect diminish.

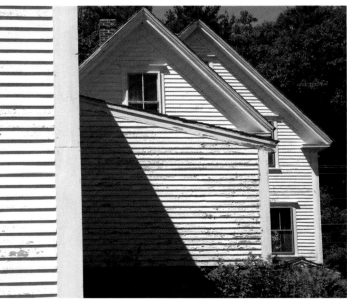

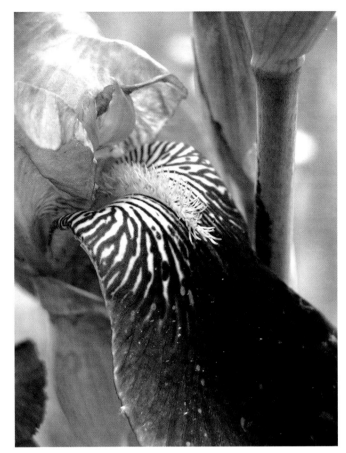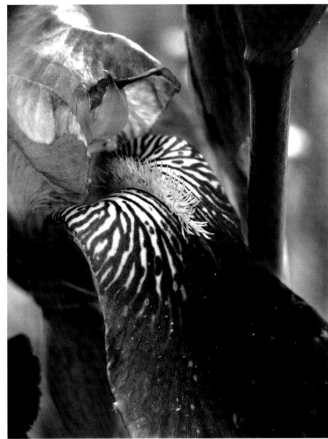

A Multiply Blending Mode can be used to increase image density by about a stop. You access Blending Modes either through the Layers palette or through a New Adjustment Layer. This image required a bit more density, which a Multiply Blending Mode supplied immediately.

many, in my view, points out that you've made things too complicated. Layers do provide endless possibilities for modifying your images: You don't touch the base, or background image, when working with Adjustment Layers, so you're able to play many "what if" games without disturbing the original information. Plus, you can turn the effect of each layer on and off to see if you like the result as you work. (In Photoshop you do so by clicking the eye icon next to each Layer on and off.)

BLENDING MODES

When you are working in Layers, you can choose what are known as Blending Modes to work with contrast and exposure adjustments. (In the Layers menu, choose Levels, and you will see a box labeled Modes; click on the arrow, and options to work in many different modes will appear.) Each Mode creates a specific interpretation of the image and provides a different correction technique. Here's what the three Modes I most commonly use do.

• Multiply increases exposure by about a stop. As in darkroom printing, you get a darker print and more density

as you increase exposure. This increase in density, however, does not change contrast. I have used Multiply very successfully to add density to underexposed images and to restore faded prints; in fact, this tool is invaluable in rescuing faded images from the old family album.

• Screen decreases printing exposure by about a stop. As in darkroom exposure, you get a lighter version of the image as you decrease exposure, without a change in contrast.

• Overlay is a quick contrast control and changes contrast by about one stop. (This would be like changing contrast grade in the chemical darkroom by +1, such as going from a grade 2 to a grade 3 paper or filter when using variable contrast paper.) The exposure does not change, even though the increase in contrast makes the print appear darker.

The best way to see the effects of these Modes is to put an image up on the screen and try each Mode. You'll see how quickly these Mode applications affect your image and how they can make a big difference in how you work going forward.

LAYER MASKS

This is one of the most valuable tools at your disposal. It allows you to combine various elements of the different Layers you have created.

In the photographic darkroom, masking is a technique that works with some form of light resist—film or dye—to control contrast or exposure on select portions of the image. Masks are (or were) used extensively by commercial printers, although fine art printers knew the trick as well.

The digital darkroom equivalent of this technique is a Layer Mask, one of the most important tools at your disposal. You use Layer Masks to reveal the Layer (or Layers) beneath the Layer you have created to apply an effect; in

this way you can incorporate different elements of the various Layers you have created. Let's say you have created a Multiply Mode of an image and it becomes darker. However, you don't want the entire image to go dark, just select portions of it. The first step is to make sure that you've highlighted the Layer you want to work on, the active image, in the Layers palette. Make sure a Layer Mask is available (check that the icon is in the active Layer). Next choose a brush and literally paint away the areas in the ac-

These chemical tanks on the outskirts of Kalispell, Montana, could use a bit of contrast and exposure help. The first step was to open up the contrast and exposure on the white tanks using a Screen Blending Mode (below). The next and final stage was painting back the sky using the Layer Mask technique (page 87). The Layers palette shows these simple steps. Note the Layer Mask icon (the circle within the rectangle) in the active (blue highlighted) Layer (below). This mask is automatically inserted when you make an Adjustment Layer. For other Layer types, such as a duplicate Layer, you have to create a mask. You do this by making the Layer active by clicking on it, then clicking on the mask icon at the bottom of the Layers palette.

tive Layer you want to eliminate. You need to check the foreground/background color boxes at the base of the tool palette and make sure that black is in the foreground box.

When working with Layer Masks:

- You can choose any size brush and brush edge you like. (An easy way to change the size of a brush is to use the bracket keys. Press the right bracket key to enlarge the brush and the left key to make it smaller.)

- You can use Layer Masks to change the opacity, or degree of effect of each stroke. At 100-percent opacity you go right down to the lower layer with one stroke; at lower percentages you can paint back with any degree of effect that you desire.

- As you brush back you should consider using the zoom tool to get closer to finer areas within the image, especially when tonal areas are close and there is a lot of detail within the image. If you overstroke, or affect an area you did not want to change, it's easy to paint the area back. All you need to do is flip the foreground color box so white appears as the foreground color; you do so by clicking on the small toggle arrows in the box. You then paint back to the original value or, setting the opacity higher or lower, modify your Mask.

- You can fill the Layer Mask with black, simply by holding down the Alt (Option) key when you create a Layer Mask. This reverts to the original image and allows you to paint in the effect.

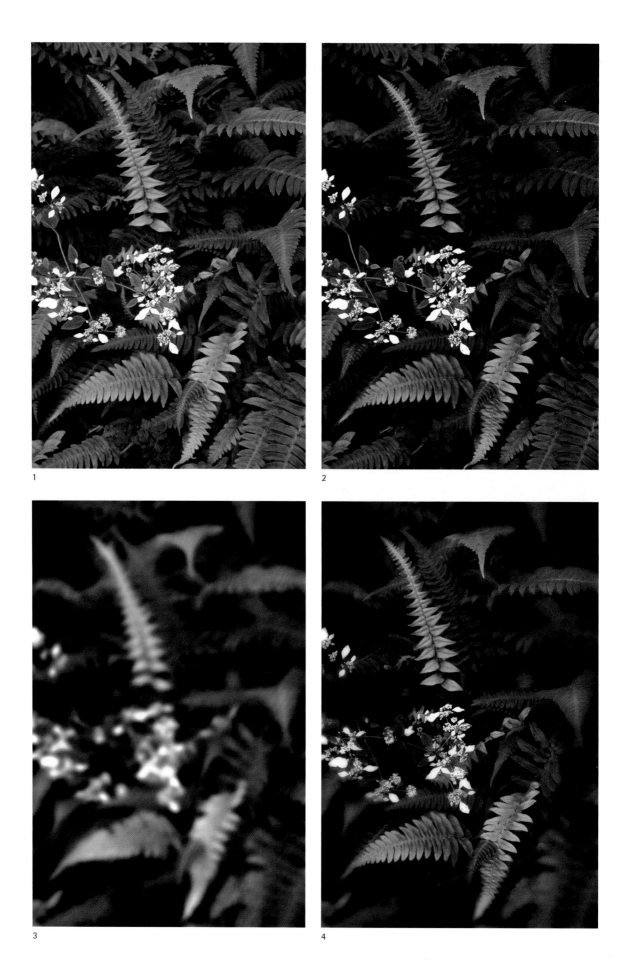

1

2

3

4

Layers and Layer Masks are key to very fine image enhancement and correction. You can combine effects and use numerous Layers to get the effects you desire. First I gave this image of a cluster of ferns (**1**) more density by applying a Multiply Blending Mode to the first Levels Layer (**2**). I set the Layers palette Opacity slider at 47 percent, which yields about half the full +1 density effect otherwise obtained. I then created a Duplicate Layer (Layer>Duplicate Layer) and applied a blur filter (**3**). I created a Layer Mask in that Layer by clicking on the Layer Mask button (second from the left at the base of the Layers palette) then erased some of the blur using a Paintbrush tool (**4**). I made a final tweak (**5**) by applying another Levels Layer to lighten the overall exposure. The Layers palette shows the Layers I used and how the Masks were defined (**6**).

5

6

This scene, shot in Tent Rocks, New Mexico, shows how you can adjust both exposure and color tone using Layers. The original image is reproduced on the far left. Subsequent steps are shown left to right. The first step is to apply a Multiply Blending Mode then paint back certain areas to get the desired tonal values. After achieving a tonal balance, I painted certain areas back using a Layer Mask. Then I added another Layer (Layer>New Adjustment Layer>Hue/Saturation>Colorize) to create a warm brown colorization.

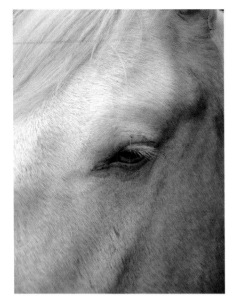

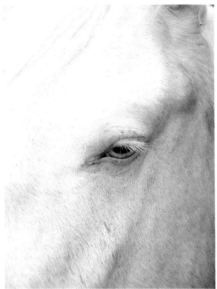

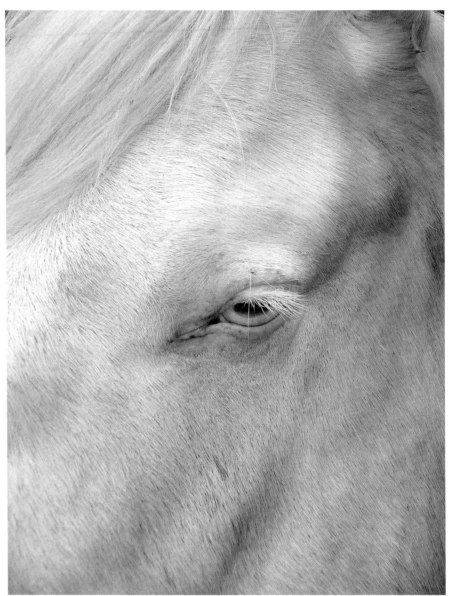

Layers and Masks allow you to refine images in many ways. I made this closeup of a horse (top left) with a digital camera and applied a Screen Blending Mode to open up the image (above left). Then I applied a Layer Mask and painted back some areas for a different interpretation (top right). The History palette shows the steps and strokes and the Layers palette shows the effect of using just one Layer and the accompanying Mask. To me, this is the simplest and most direct way to have tonal, contrast, and exposure control over an image

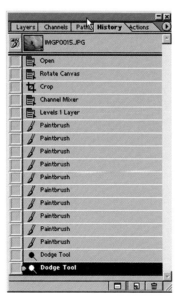

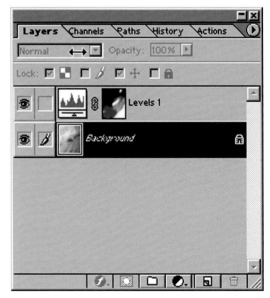

BURN AND DODGE TOOLS

Burn and Dodge tools provide an easy way to do touch-ups and make quick fixes of highlight and shadow areas within an image.

When you open the Burn and Dodge tools, look at the menu screen and find the Range and Exposure boxes. Range controls allow you to choose highlights, shadows, or midtones. In essence, these ranges define the tonal values the tool will affect to the exclusion of the other values. For example, choosing highlight allows you to dodge a highlight area without affecting the other tones. Likewise, by choosing shadow, you can burn in a shadow area without changing the highlights.

Exposure determines how effective each stroke will be. In general I keep the exposure quite low—usually about 15 percent. This way, I can build up density when burning or decrease density when dodging in gradual steps. I have much more control as a result. I do not stress using Burn and Dodge tools, as I feel that most of the effects I seek can be attained using Layers and Blending modes. I do use them sometimes to touch up an image and do some final refinements. For example, I might use the Dodge tool to brighten eyes or add gloss to lips in portraits and the Burn tool to finish up an edge burn. If I do use these tools, I always do so on a Duplicate Layer, so any miscues do not affect the background image information.

THE DIGITAL ADVANTAGE

Burn and Dodge tools allow you to add or reduce density (exposure) in select areas of the image. In the traditional darkroom, you add or hold back light by using your hands, cardboard, and various wire-attached tools. The process requires lots of patience and testing and you don't know if you've achieved the desired effect until you've run the image through the developing bath. The process is much easier in the digital darkroom, because:

- You see what you get when you apply the effect, stroke by stroke.

- There's no need to process the print to see results.

- You can modify and control the techniques to very finite degrees.

- You can burn and dodge different levels of tonality without affecting others (for example, you can burn a highlight and have no effect on a shadow area right next to it).

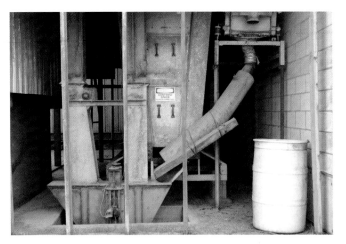
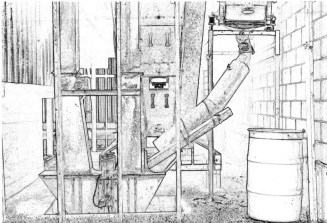

This industrial scene (top left) got a special effects treatment when I applied a Find Edges filter (Filter>Stylize>Find Edges) on a Duplicate Layer. I then applied a Layer Mask and painted back portions using a Paintbrush tool (bottom).

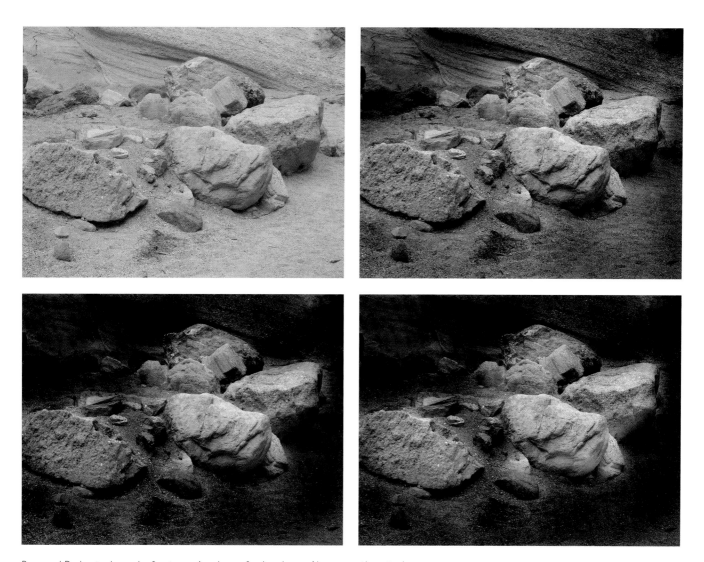

Burn and Dodge tools can be fun to use in a loose, freehand way. Always use these tools on a
Duplicate Layer. This set of images displays the process of "painting in density" using the Burn tool
set on Midtones, 18 percent. When working with these tools, keep the exposure low, as this gives you
more control. Strokes are cumulative, so you can go as dark or light as you want in a gradual fashion.

LEVELS AND CURVES

Levels and Curves allow you to maximize tonal spread, or to compress it for various image effects. You can also use these tools to open or compress very specific tonal areas.

LEVELS

Levels controls work with a histogram readout of the range of tonal values within the image (see page 78 for more on histograms). Levels displays the contrast range and lets you modify it, then redistributes the tonal values throughout the image. When you have an image on the screen and open the Levels dialog box, you'll see a graphic representation, a histogram, of the range of tones in the image. Going from left to right are the shadow-to-highlight values, with 0 being black and 255 being white. Using sliders, you can adjust what are known as the black point and the white point—that is, the darkest and lightest parts of the image—and the midtone grays.

Open Levels and apply the controls to a variety of images. Note how the tones are distributed, then move the sliders to see how the contrast changes. Move the White Point slider to the left and you will see the contrast increase in the highlights; move the Black Point slider in and you'll see the darker values become deeper. What you are doing is actually compressing the tonal values of the image, changing the spread of tones by working with contrast.

The Middle Gray slider is probably of special interest to anyone who has worked in a chemical darkroom. When you set an overall contrast range with the Black and White sliders you are defining the parameters of highlights and shadows; you change those values with the Middle Gray slider. If you move the slider to the right the image becomes darker; to the left it becomes lighter.

Another control you'll find in the Levels dialog box is Output. This contains only Black Point and White Point sliders. If you go to print and find that highlights are out of control, you can move the White Point slider in to put a slight veil over the image and tone down the highlights so they gather some ink on printing. Similarly, you can do the same with shadow areas. This is a fallback position if you just can't get the values right and want to do a quick tweak before printing.

CURVES

Curves allow you to control both the overall contrast and distinct tonal values within your image. I could write a book just about Curves, but for now let's look at them as a contrast and tonal-value control tool.

The Curves dialog box looks very much like the classic tone curve used to plot photographic exposure and the resulting density. The diagonal line shows a progression from dark to light values from the lower left to the upper right. Play around with the Curve and you'll see how much you can change an image with just a few movements.

If you want to change the value of a specific set of tones, open the Curves dialog box, move the cursor into the image, and click on it while you hold down the Control key (the Command key on a Mac). This locks the point on the curve that indicates those specific tones. Then you can move the point up or down from the diagonal line to lighten or darken that value, respectively. For example, say you have a portrait where the face is shadowed by a hat and you want to open up that area. All you need to do is click on the image while holding down the Control (Command) key, then move the point up until you get the value you want. Do this with restraint, as too much of a correction whacks out the curve and can cause some very odd effects.

It might take some practice before you're comfortable using Curves. But you'll probably soon find that they are fairly addictive and offer controls that can help you enhance every image.

The Curves dialog box is one of the most powerful image adjustment tools. You can access it at Image>Adjust>Curves, or the preferred method, Layers>New Adjustment Layer>Curves.

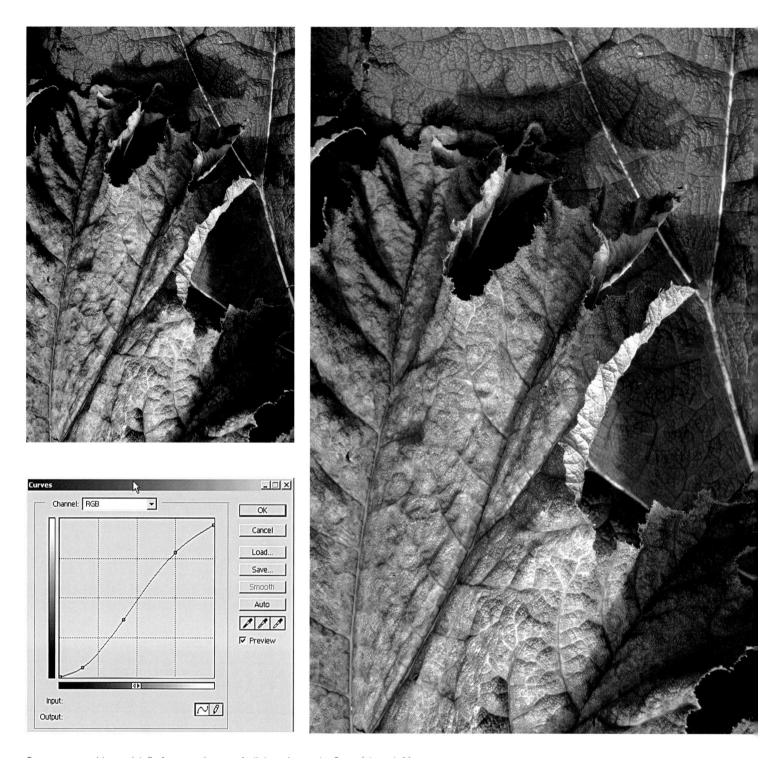

Curves can provide a quick fix for many images. A slight twist on the Curve (above left) opened up the middle values in this close-up of a leaf; all I needed to do was hold down the Control (Command) key while clicking in specific middle tonal values.

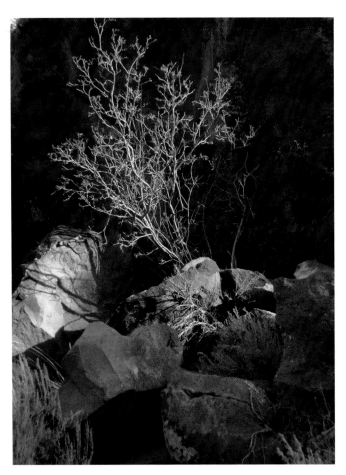
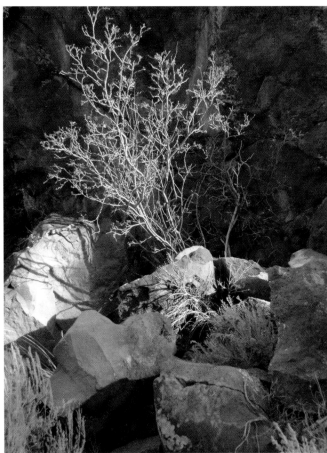

This photo shows a lot of contrast and needs adjustment in both highlight and shadow areas (top left). The best method for correcting images is first to take care of the foundation values (those that might dominate considerations when printing), then to deal with the rest of the image. Here, I dealt with the shadow areas (the lower portion left of the curve; top right) and then used a Duplicate Layer to burn down the highlights (opposite page).

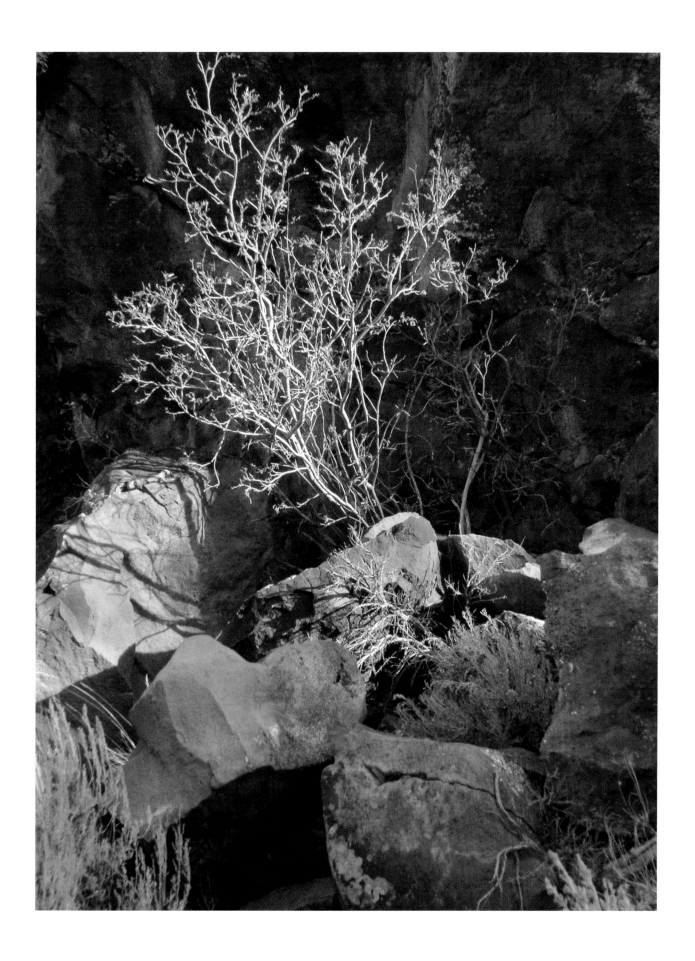

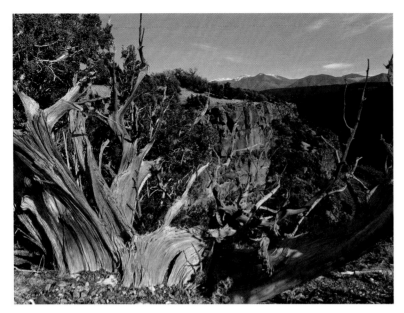

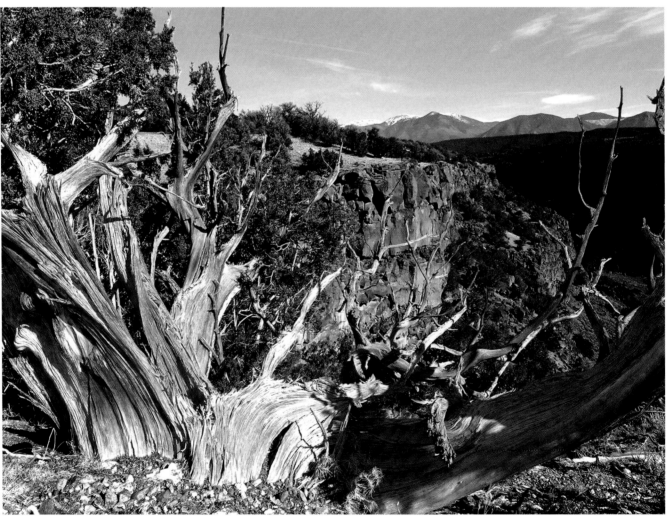

In this landscape photo, a slight movement of the
Curve gave just the contrast kick I wanted.

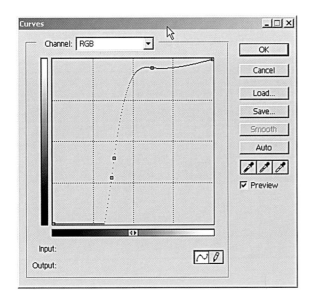

A photo like this is often best left behind, but I show it here to exhibit the amazing power of Curves controls. This is a fairly odd curves change, but it did the job.

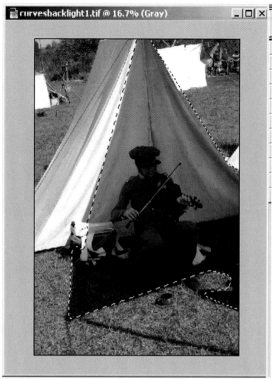

I photographed this fiddler in the shade of a tent (above), creating a backlit situation. So, I selected the shadow area (a process that identifies an area to be changed while protecting other areas from change; see page 116) then opened up the shadows using Curves controls.

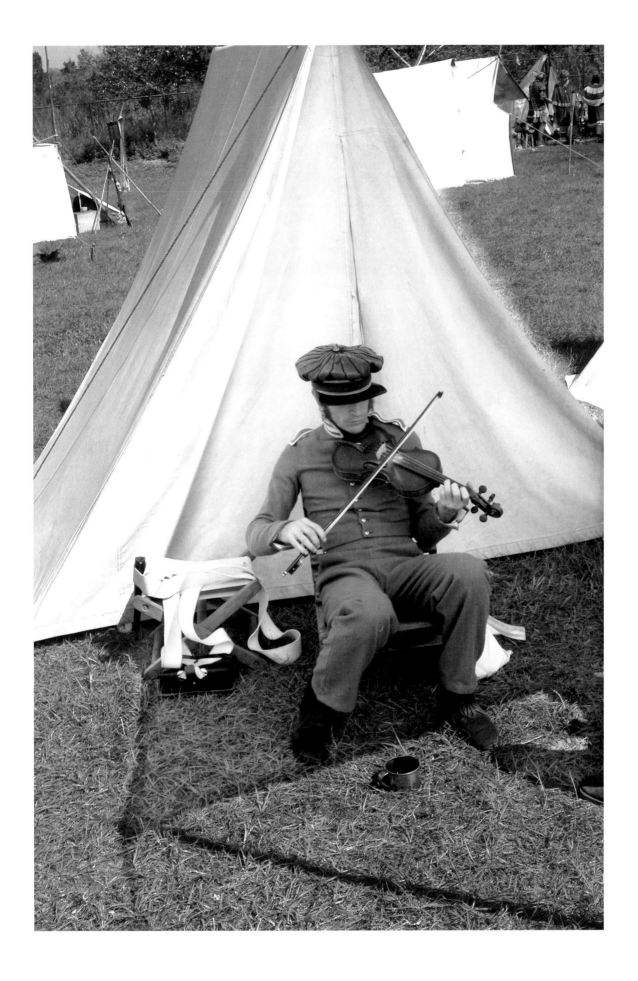

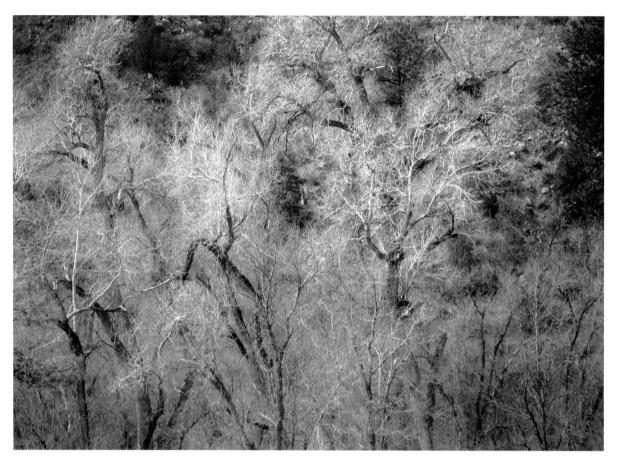

This photograph of trees has a good range of values but I wanted to play with its possibilities. I opened up the highlight and shadow areas with a bowed curve. When I chose the Curves control as an Adjustment Layer, the program created a Layer Mask in the Curves Layer. I then painted back the image to get a variety of values and tones. Here's the Layer palette that shows the steps.

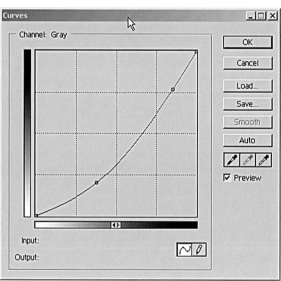

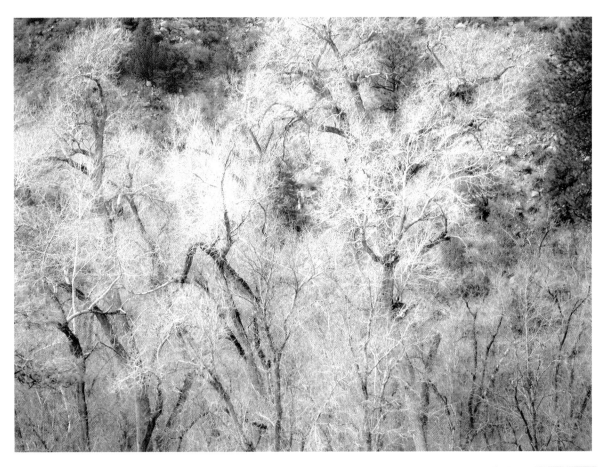

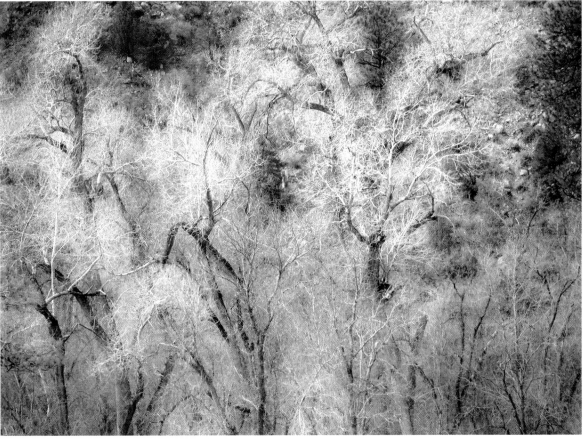

TONAL GRABBERS AND FILL TOOLS

Fill technique provides a way to manufacture tonal value and can be invaluable when working with burnt-out highlights that essentially have no detail.

If you were working in the chemical darkroom, you would use a technique known as flashing, or fogging, to bring some tone other than paper white to the overly dense areas of the negative. In the digital darkroom, fill technique is an alternative to lifting a tone from one part of an image, or another image, and adding it to another area that has no detail.

Images that have been exposed incorrectly, overdeveloped, or badly scanned often lack detail. To correct them with fill technique, you'll use the Eyedropper tool, found in the toolbar. Move the cursor, which becomes the eyedropper, over the tonal value you want to pick up. When you click on the mouse you'll notice that the foreground color box loads the tonal value of that area. Select the area in which you want to add that value and go to Edit>Fill. From the dialog box choose "foreground color" and an opacity of about 15 percent (this way, when you fill the value over the image, you won't obscure the detail beneath it). Click "OK" and the area will fill up with the tonal value you've selected.

This image of a waterfall recorded with no highlight texture. Rather than let the area go to paper white when I made the print, I decided to give it some density with gray fill. First, I selected the waterfall using a control known as Color Range (found in the selection submenu) then added gray fill with a low opacity using a Color Fill Layer. Then I inverted the selection and added some tonal variety to the rock wall. The Layers palette shows the steps.

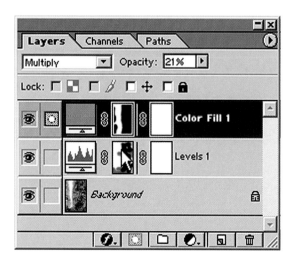

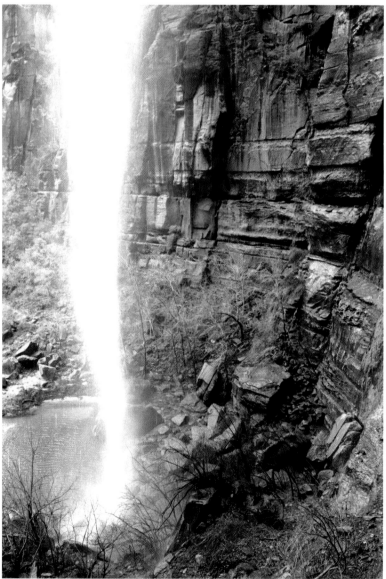

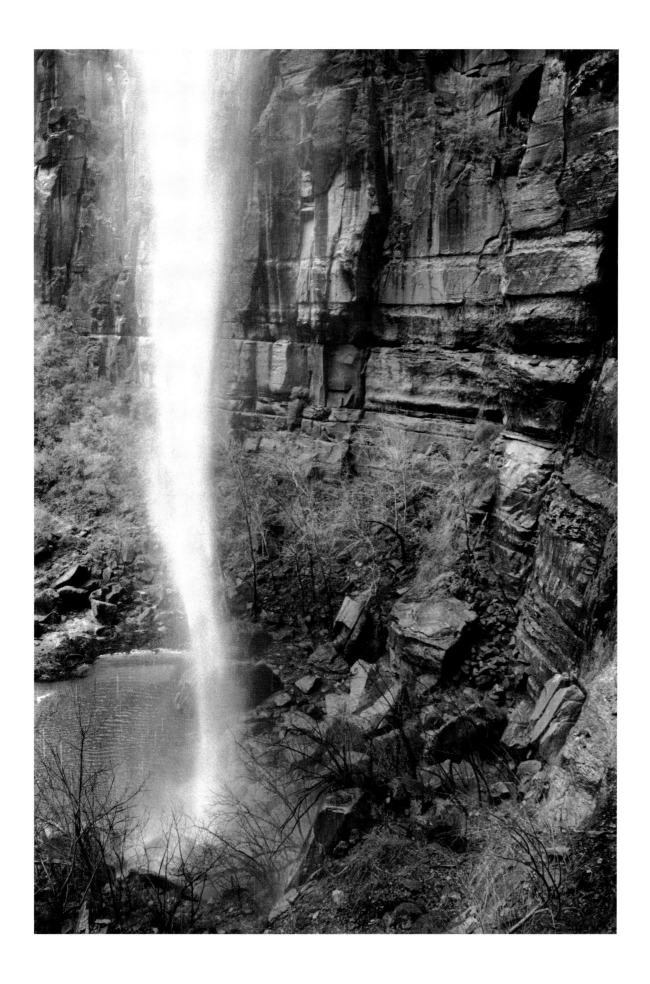

In this photograph of aspen bark (top left), the highlights recorded too brightly. I chose a Fill Adjustment Layer (Layer>Color Fill Adjustment Layer) and selected gray at a low percentage (too great a percentage would obscure the image) to adjust the highlights. I then painted back some of the highlight areas for a better effect, using a Paintbrush tool with a low opacity to have more control.

WORKFLOW

Simply put, workflow is the "order of march" you use to work on your digital image files. When you first put an image up on the screen, you should reflect for a moment on just how you can apply the tools at your disposal. Consider what might best suit the image and how each tool and technique can be used to correct flaws and enhance the image. Each person defines his or her own best way of working, depending on internal logic, but the aim is to simplify the work so that it goes smoothly and that each step follows the next.

In some cases the steps you take will follow their own course and reinforce your instincts on how you'd like the image to be completed. In others you should allow yourself some room for experimentation and surprises; this will give you more creative space and bring you along routes that will lead to entirely new types of visual expression. The beauty of digital printmaking is that you are encouraged to make such creative forays, as you can always double back using the History palette and Undo commands as you go. In addition, working on Layers lets you modify each step as you go.

In order to help you establish your own personal workflow, here's an example of how I worked on one image, a candid portrait photographed with window light. You might find other ways to work on this image. As you work you'll discover your own best workflow and apply it to the types of looks and tonal plays that best suit your own images.

1. The original image was made with a digital SLR. Window light comes from the side and to the left of the subject. This was a fairly quick candid, and after bringing it up on the screen I noticed that there were distracting elements coming from right behind the head of the subject. My first job, I knew, was eliminating these and controlling the light.

2. I made a duplicate Layer (Layer>Duplicate) and then opened the Gaussian Blur filter. I moved the slider fairly far over to the right until I saw the amount of blur that would get rid of those distracting elements.

3. Here's the look on the screen after application of the Gaussian Blur effect. I didn't remove the distracting elements completely, but my efforts got me close enough. I knew I would work more on these problems later.

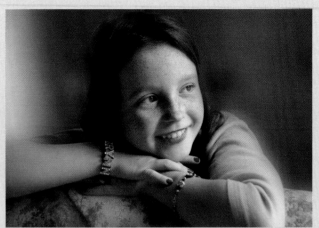

4. Being a Duplicate Layer, a Layer Mask wasn't automatically inserted into the Layer. I added one by clicking on the Layer Mask icon at the base of the Layer palette. In order to "paint in" the blur, I wanted, in essence, to invert the blur effect. So I held down the Alt key (Command key on the Mac) when I clicked on the Layer Mask icon. This filled the Layer with black.

5. I then proceeded to paint in the blur effect. When I went too far over the subject with the paintbrush, I reversed the foreground and background color and painted in the clear area.

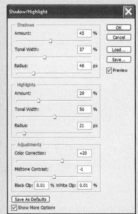

7. I wanted to play with the tonality, so I experimented with the Highlight/Shadow tool (Image>Adjust>Highlight/Shadow) a bit. This was a slight adjustment but helped open up the shadow side of the face just enough.

6. My next step was to convert to monochrome using the Channel Mixer. I moved the various Channel Mixer sliders around until I got close to the look I wanted.

8. To further play with the contrast I opened up Levels on an Adjustment Layer and tweaked the white point a touch toward the center. This firmed up the values to exactly where I wanted them.

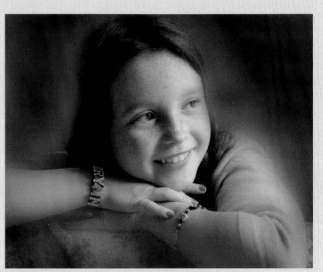

9. I then cropped the image to remove any distracting tones at the edges, and burned down some of the corners with a few strokes of the Burn tool at Midtones/18 percent.

SHARPENING AND SOFTENING

Sometimes you might want to sharpen, or pep up, an image slightly. Or, you might want to soften certain areas of the image to obscure distracting backgrounds, enhance portraits, or create depth of field.

SHARPENING

In essence, sharpening affects the edges of pixels and creates an illusion of a snappier image by increasing the contrast of these edges. The tool for sharpening is the Unsharp Mask Filter, an oddly named process for sharpening that actually means that you are masking out the unsharpness. In Photoshop you'll find the filter under Filters>Sharpen>Unsharp Mask. When you choose the filter you get the Unsharp Mask dialog box, which has three sliders for Amount, Radius, and Threshold.

- The **Amount** is how the filter is applied and how much the differences at the edge of the tonal borders are enhanced.

- The **Radius** defines breadth, or at what distance from the tonal edge the application will affect pixels. For many images you can keep this value at 1 or less, although when working with higher resolution images (18 MB and above) you might want to increase the value to 2, as you are generally working with smaller pixel sizes.

- The **Threshold** defines how different the tonal values have to be for the filter to affect them. In general, you might want to keep this between 1 and 7, with 1 for more detailed images, and higher for more subtle values. It's a good idea to raise the Threshold setting for portraits or when you have dominating sky in an image.

Note that there are numerous other settings available. Experimenting with the variables is key. Play with the sliders and see how each affects the image. Zoom in and out for even more critical examination and click the mouse with the cursor inside the preview box to see before and after effects. Sharpening is really a perceptual judgment procedure, and making proofs at different levels of sharpening can be very instructive.

There are a few general rules for sharpening.

- Perform sharpening after all your work on the image is done, as it may generate certain glitches that become even more apparent with some other changes you might make on the image.

- If you need to do a lot of sharpening, do it in steps. Too much sharpening can completely alter the look of an image, sometimes to the point of ruining it. Also, understand that sharpening usually increases image contrast and that excessive sharpening can give a harsh impression.

- Sharpening does not fix an image that is blurry (caused by camera shake) or out of focus. It can tighten up areas that are slightly out of focus but it's no substitute for getting the focus right when you make the picture.

Using a Layer allows you to see the results of your sharpening, since you can turn the Layer on and off as you work rather than having to use the History palette to see various versions. Create the Layer by going to Layer>Duplicate. Once the Layer is in the Layers palette make sure it is highlighted, and then go to the bottom of the Layers palette and assign it the Luminosity Blending Mode. This mode applies the sharpening to the luminance, or brightness value, of the image only. This approach does not increase saturation in colorized or toned images or zap a grayscale image.

When you sharpen you must work with a Duplicate Layer (Layer>Duplicate). Once you have a Duplicate Layer click on the Blending Mode button on the Layers palette and choose the Luminosity Blending mode. This photo of silos is prime for sharpening, as it's a bit soft and has a highly graphic look (above). Once you open the Unsharp Mask dialog box (Filter>Sharpen>Unsharp Mask) you can move around the image within the box to get a close look at lines and shapes and at the overall effect. All you need do is click and release the mouse to see the effect in preview. Be aware that over-sharpening can be quite destructive and you should avoid it (right).

SOFTENING

Softening can be quite effective in certain images. With portraits, for instance, you might want to sharpen eyes and soften skin values. Or, in a still life, you might want to add dimensionality by sharpening the object in the foreground and blurring the background. To create these effects, use a Duplicate Layer to create a softening effect on the entire image and then modify it with a Mask. Go to Layer>Duplicate Layer, then click on the Add Mask icon at the base of the Layers palette to apply the Gaussian Blur filter, found in Filters>Blur>Gaussian Blur. (This filter has only one control, the Radius, and moving it to the right increases the blurring.) Then create a Layer Mask by clicking on the Add Mask icon at the base of the Layers palette while you hold down the Alt (Option) key. The image reverts to the original (as you have filled the Duplicate Layer with black) and the foreground color box goes to white. When you paint you are actually applying the effect, the softness. If you prefer to have the image blurred and paint back to the sharper areas, don't hold down the Alt (Option) key when you click on the Add Mask icon.

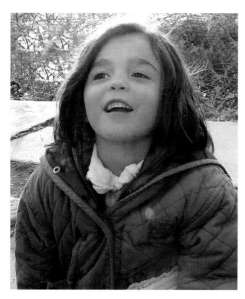

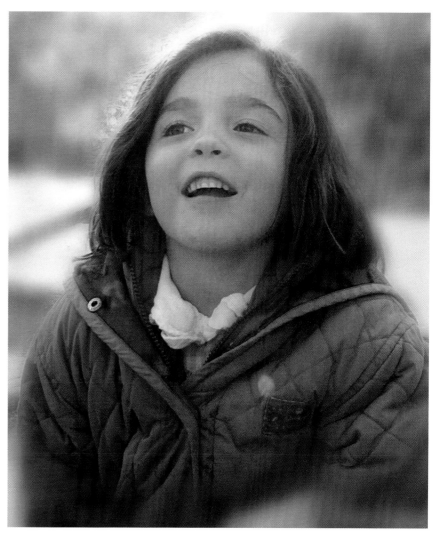

As you do when you sharpen an image, you use a Duplicate Layer to soften. In this image I wanted to soften the background (upper left). I created a Duplicate Layer and then went to Filter>Blur>Gaussian Blur and used the controls to soften the entire image to the point where the select area was as soft as I wanted it to be (left). I then added a Layer Mask to the Duplicate Layer and painted back the areas I wanted sharp. If I wanted to work from sharp to soft I could have held down the Alt (Option) key when I clicked on the Layer Mask button and filled the mask with black, then painted back to the softness in the areas I desired (above).

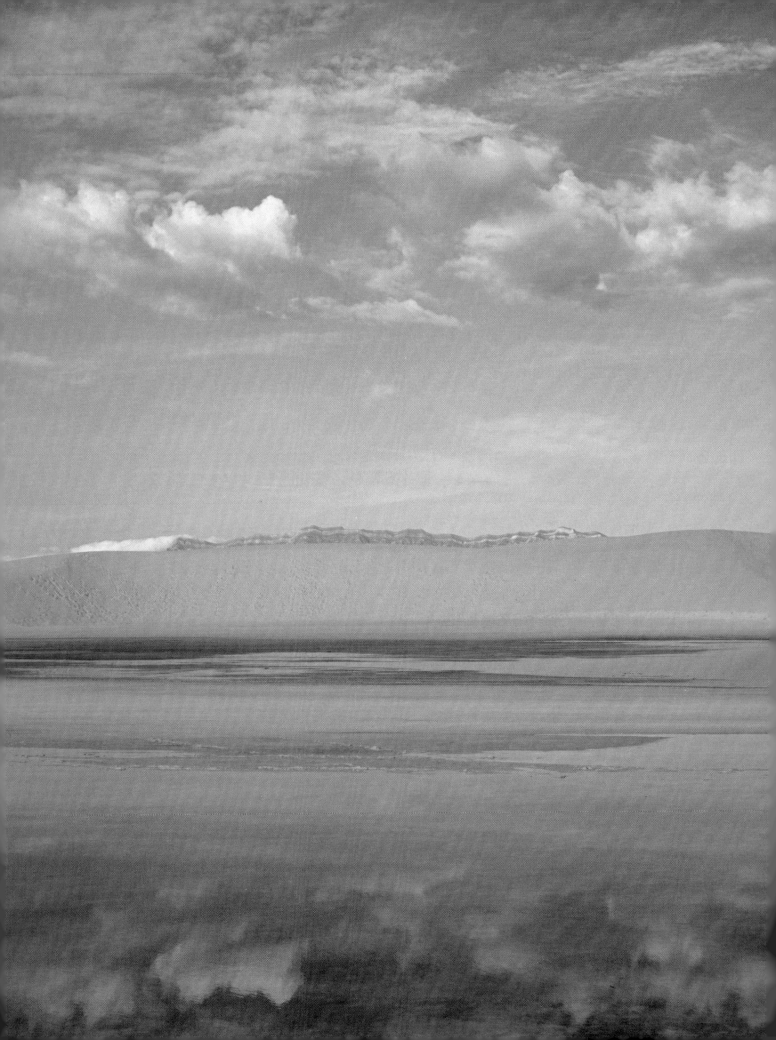

SPECIALIZED TOOLS

At times you might want to isolate sections of an image and work on them exclusively. Selection tools and modifiers allow you to do so. Meanwhile, toning and colorizing techniques make it easy to add color to your images, without exposure to darkroom chemicals.

SELECTION TOOLS

These tools help you select parts of an image and modify them while protecting the other parts from your changes. The process is really twofold: You select the area or like pixels on which you want to work then apply changes to that area. Selection tools are extremely varied: You'll find your favorites and quickly learn to match the tool with the job at hand.

FREEHAND TOOLS

These tools allow you to select specific parts of an image by hand, rather than going through multiple steps in software. Here's a tip when using these tools: Double click when you've completed any task with a freehand tool. If you don't, you'll get a message informing you that your selection is not complete.

- The Lasso tool is handy for a "quick and dirty" selection. If you can draw and can translate that talent to the mouse, you'll probably be able to use the Lasso easily. I use this tool to work on small areas and usually modify it with the Quick Mask aid (see page 128). I also use the Lasso tool frequently to add or subtract areas from a selection, as a sort of touch-up to the task. When working with the Lasso tool for freehand work, I use a stylus rather than a mouse.

- The Polygon Lasso tool is great for drawing straight lines around an object. Click to begin a line, release the clicker, then drag the line to the point where you wish

it to end. Continue doing this until you complete the shape you want to create, then double click to complete the selection. If you hold the shift key down as you make the selection, the lines you have created will straighten into right angles.

- The Magnetic Lasso tool helps you follow a tonal border as you trace around an object. You can work right at the tonal edge and make three settings. Frequency refers to the number of pixels at which an anchor point (an area where the selection is set) will be set. Edge contrast defines what degree of difference between tonal areas the tool will recognize. Width defines the number of pixels between the tonal areas that will be used to make the selection. You can feather the selection as well. Users sometimes have trouble with the Magnetic Lasso, as it can seem to have a mind of its own. If the Lasso goes off on a wild tangent you can retrace your steps and click to set an anchor point (to set the selection) then double click to enclose the selection.

When you open a selection tool, a toolbar appears below the main menu at the top of the screen. Use this toolbar to modify and define the selection parameters. Choose the Magnetic Lasso tool, and four boxes will appear. The first is for normal selection; the second is for adding to the selection; and the third is for subtracting from the area. The Feathering box designates the blend of the selection with the adjacent area. When you choose the Magic Wand tool, you also get a Contiguous box. Contiguous on means that the selection will be halted when a tonal border is reached; off means that all similar pixel addresses will be selected, regardless of where they sit within the image.

SELECTIONS TO THE RESCUE

You can address two classic problems with selection tools. One concerns the landscape shot where the sky is brighter than the ground. When making the photograph you might have to choose a good exposure for the sky or for the ground, or make a compromise exposure that gets you halfway between without giving you the richness you want in either part of the image. The other problem is backlighting, a common woe with

portraits that occurs when the subjects falls, as it were, into its own shadow. Yes, you can use fill flash, and yes, you can reposition yourself or the subject to avoid this problem (or just wait for the right light!) but that's not always possible. While some of these problems can be solved with the Highlight/Shadow control (available only in Photoshop CS) or by painting in and out with Masks, selections are the easy way to go.

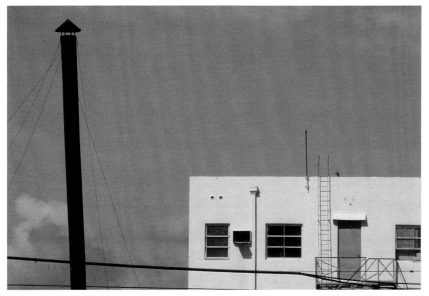

The Polygon Lasso tool is perfect for selecting box-shaped objects, such as this factory building. A click begins the selection; after clicking simply drag the tool to the next corner, then click again and follow suit until you have enclosed the shape. This series of images shows how changes can be made easily using this selection tool.

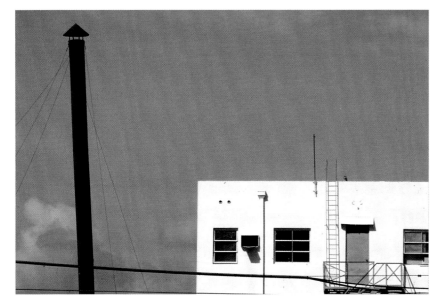

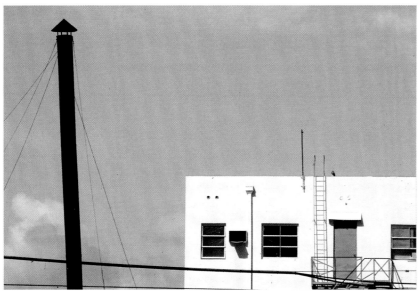

SHAPE SELECTORS

The Shape Selection tools include the Elliptical and Rectangular Marquees and are handy tools for working with architectural images and images with horizon lines. The Elliptical Marquee is great for drawing round shapes—from ovals to circles to egg shapes, and I often use this tool for faces. I also use it for edge-burning, where I want to add a slight darkening (without obvious vignetting) to the corners of my print. The Rectangular Marquee is very useful for horizons and square and rectangular objects. I will feather as needed and often modify these selections using the Add, Subtract, and Quick Mask Modes (see page 128).

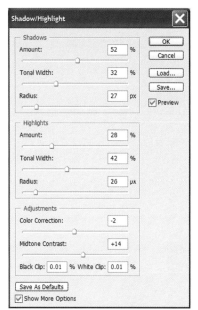

The latest version of Photoshop has a magical selection/exposure tool known as the Shadow/Highlight control (Image>Adjust>Shadow/Highlight), which can be used on a Duplicate Layer. The corrective steps are largely perceptual—you move the sliders in the dialog box to get the look you want. This image of a desert plant began as a fairly "flat" scan (above left); I changed the sliders (left) to open up the tonal values without having to make a selection with the Magic Wand or another selection tool.

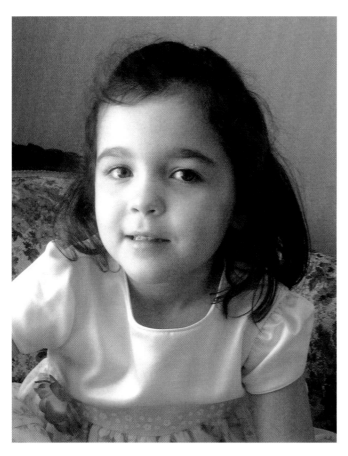

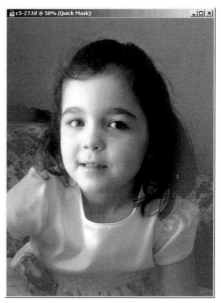

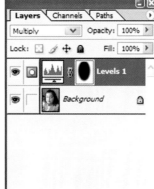

You can use the Elliptical Marquee to create vignettes, which I use for edge-burning. One of the best uses of edge-burning is to create a center of light on portraits, which adds a more dimensional feeling to the photo. I made this picture with window light. The effect is nice, but the background has the same light value as the foreground (upper left). When I made the selection with the Elliptical Marquee, I feathered at a value of 22, which helps blend the selection, shown here in Quick Mask mode (above). I then used Levels (the dialog box shows the mask created by the selection; left) to create a nice darkening vignette around the subject (below left).

The Rectangular Marquee tool is great for making quick selections of square and rectangular shapes, such as this window in Curaçao that I originally photographed on color slide film. After selecting the outside wall, I desaturated the color using the Hue/Saturation control (right) to yield a near-monochrome image (above right). Then I inverted the selection to open up the remainder of the image to change (opposite page).

SELECTION VIEWING OPTIONS

When you select an area the selection shows up as a series of active dashes, sometimes called a "marquee," because they look like the lights on a theater marquee, or simply as "marching ants." If these lines get in the way of your making fine decisions about the nature of the work, you can go to View> Show Extras and unclick that option. You can then do the work and see a preview of what you've done without the interference of the selection outlines. The area is still selected, but the graphic outlines of the selection have been taken away. This feature is invaluable when you want to edge burn using the Elliptical Marquee or when you've selected so many small areas that you can't make sense of it all.

PIXEL ADDRESS SELECTORS

These tools allow you to work on specific groups of pixels within an image, so you can change one tonal value (or a defined range of values) throughout the image, regardless of where the value resides.

- You can use the Magic Wand as a basis for many tonal variations in a scene. Select it and place your cursor over any tonal value in the image and modify your selection for contiguous or non-contiguous (see page 126)

as well as other parameters (Tolerance is the most important; see page 126). In this way you can select a bright sky or other bright highlights you want to darken, or dark tones you want to lighten. Choose a low tolerance for images where there are lots of fine lines and a higher tolerance for general tonal areas.

- Color Range, found under the Select menu, allows you to pick out a general range of values within an image and select them. The main options are highlight, shadow, and midtones. For example, say you want to select a bunch of white highlights in flower petals set against a dark plant; all you need do is go to Select>Color Range>Highlights and click, then select every small petal.

- The Eyedropper tool is not a selection tool in the proper sense of the term, but is an invaluable ally of selection tools. Let's say you have selected a dull, washed-out sky with your Magic Wand and want to fill it with a darker tone. All you need do is pick the selected tonal value from another part of the image, then, using fill from the edit menu or using a fill Adjustment Layer, do an Edit>Fill into the sky. Keep the fill opacity low, at about 20 percent, rather than painting over any details that might be in the area you have selected.

Use Color Range, under the Select menu, to pick out and modify color. For black-and-white printers, there are three interesting options: Highlight, Shadow, and Midtones. In this photo (above left), made in very bright light on one of the islands off Hong Kong, the highlights are a bit "hot." So, I set Color Range at Highlights and used a Levels adjustment to bring them more under control.

To define tonal borders between the brick face and the wood on this textural wall, I dragged the Magnetic Lasso tool along the borders and double clicked when I had enclosed the area on which I wanted to work. Then I used a Levels adjustment to darken the brick face.

SELECTION MODIFIERS

Like many tools, selection tools have modifiers that help in getting just the type of selection you want. These modifiers provide many ways to define the parameters of the selection before you make it and to modify your selection once you have made it.

FEATHERING

Feathering defines how a selection will blend with its surroundings. This tool extends the area of your selection but does so with decreasing opacity. As a result, the selected area flows more naturally into the unselected area. You can feather before or after you make a selection and when you choose a Shape Selector or a freehand tool. Go to Edit>Feather and you will be prompted to select a number—the lower the number, the more distinct the boundaries between selected and unselected areas will be. If I am selecting an object that I want to silhouette, I use a lower number; if I am selecting a horizon line, I set a higher number because I don't want a hard edge between the ground and sky.

Once you make the changes on an image, take some time to consider the implications your editing has on the rest of the photo. You might, for example, deepen a sky and then notice that the logic of the light requires some modification of the rest of the photo. This is where Select>Inverse comes into play. In this scene I wanted to strengthen the sky (above right). I made a selection with the Polygon Lasso tool along the horizon line with a Feathering of 22 for a soft blend, shown here in the Quick Mask mode (below right). I then used Levels to adjust the sky (above, far right). I realized that the ground portion was a bit out of sync, so I inverted the selection and made a slight adjustment to the area (below, far right). This technique works especially well when you need to adjust an image in two or more tonal areas and don't want to make an adjustment to the entire image at once.

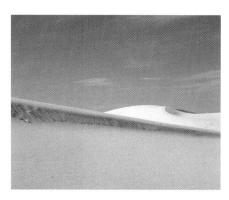

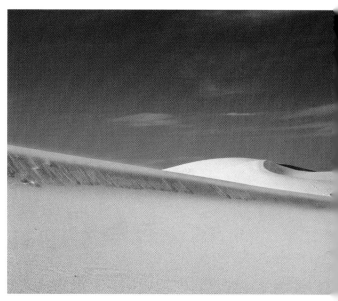

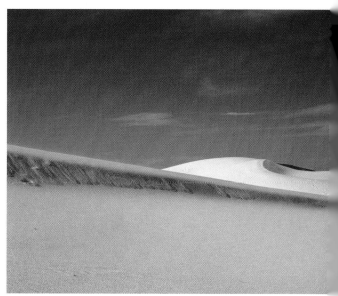

In some lighting conditions, such as those beneath an overcast sky, the exposure can cause the sky to go blank. In this scene I wanted to add density to the sky to keep it from staying paper white (top left). I used the Magic Wand to select the sky (top right) then used the Eyedropper tool to pick a gray value from the scene, which placed that value in the Foreground Color box. I then created a Duplicate Layer because I wanted to be able to modify the value later. I then went to Edit>Fill and chose a fill percentage of 50 percent and clicked OK, and the sky filled with the value (middle right). I then modified the value to taste using the Opacity slider in the Layers palette, moving it back to 40 percent (bottom right). This gave me just the density I wanted (bottom left).

TOLERANCE

You'll use the Tolerance modifier when working with pixel address selector tools. The Tolerance modifier determines how similar pixel addresses must be in order to be selected. This tool will only pick up pixels that are very similar, but you can expand the definition of pixels to be included in the selection by choosing a higher Tolerance figure. For example, let's say you want to change the values in a sky and want to select so you protect other portions of the image from your changes. The sky might be uniform or it may have variations. By using the tolerance modifier, you will be able select all the areas of the sky on which you want to work.

ADD AND SUBTRACT

Let's say you are using the Lasso tool and when you make your drawing you miss a spot. Simply click on the Add Selection box on the menu toolbar and draw in your addi-

tional area. You can also use this modifier to add an area of selection in another part of the image that is not near the part you've already selected. Conversely, if you draw over an area that you do not want to be included in your selection, you can click the subtract box and draw around the area to eliminate it. You can use this modifier with any selection tool.

CONTIGUOUS/NON-CONTIGUOUS

When you make a selection with a Magic Wand you can choose contiguous or non-contiguous options. The contiguous option determines that the selection will affect all like pixels until the pixel group meets a different tonal edge. For instance, you choose to select all gray pixels until they meet a deep black line. The non-contiguous option directs the selection tool to choose all like pixels throughout the image; the selection will not be constrained when it meets a tonal border.

When you work with the Magic Wand, use the modifiers in the selection toolbar to work in a Contiguous or Non-Contiguous mode. Scenes such as this point out the tool's usefulness. In this selection, Contiguous blocked the Magic Wand from moving across tonal borders (left). I turned Contiguous mode off to select all similar pixels throughout the frame (right).

GROWING SELECTIONS

This modifier helps refine selections that might be a bit off by expanding the range of selection to all adjacent pixels within a tolerance range that you set. You can set the number of pixels you want to grow (or shrink) with the Select>Modify>Expand (or Contract) menu item. You can also expand the pixel selection to include all similar pixels in the image by using the Select>Similar command. To nudge the selection slightly in any direction, use the up, down, and side-to-side arrow tools on your keyboard.

SELECT INVERSE

By inverting a selection, you remove protection from a part of an image you've worked on previously and protect the part you're currently working on. This way, you can apply changes to other parts of the image to create visual harmony. This modifier is very useful when you want to create tonal consistency throughout the image.

QUICK MASK

Here's a great way to check and refine the selections you've made. After you make a selection, go to the toolbar and click on the Quick Mask Mode. The area you selected will turn red (you have the ability to change the color of the Mask and even its transparency). You then modify the selection, using a Paintbrush tool to add to it and an Eraser tool to subtract from it. Use the Zoom tool to get a closer look at the selected area as you work. After you have made the refinements, return to normal viewing mode.

It was difficult to print this photograph from a scanned 35mm negative in the chemical darkroom, because the foreground was so bright and the shadow areas were so detailed (left). Burning and dodging took lots of time and required many test prints. The Shadow/Highlight tool, however, made short work of printing this image well (right).

Use Quick Mask mode to verify a good selection. You can switch from a normal view of the marquee (the moving dash lines around your selection) by clicking on the Quick Mask mode button at the base of the toolbar. Once in this mode you can add to the selection by painting with black as the foreground color (as shown) and subtract from it by inverting the foreground color to white. In this scene I wanted to maintain the tonal values on the trailer and darken the background (above). First I selected a rectangle around the trailer (to make for less painting) and switched to Quick Mask mode (far right). I then added to the selection by painting in around it, zooming as I worked. Here are some steps from the work in progress (opposite page, upper right and left). I then inverted the selection so that I could affect the background and protect the trailer from changes, and used Levels to darken the area (opposite page, bottom).

c5-23.tif @ 16.7% (Quick Mask)

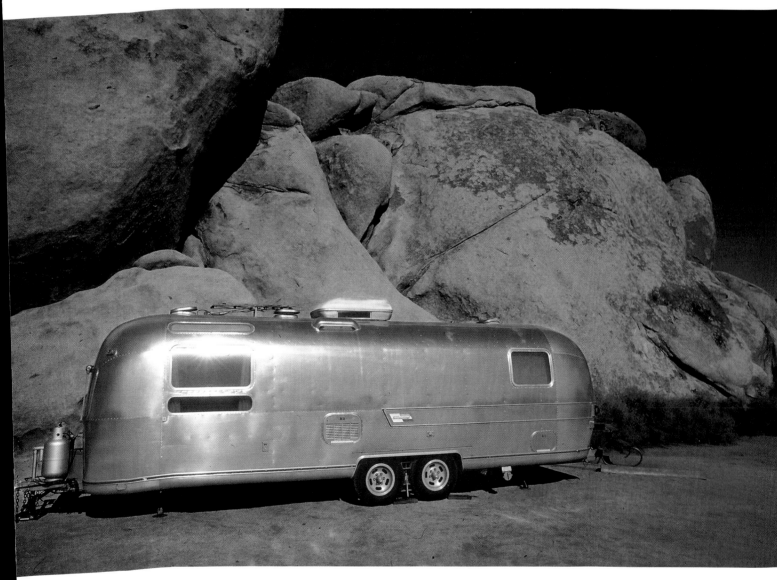

You can use many hidden selection tools, disguised as exposure or contrast controls, to play with images. You can use them in combination with masks to make many interesting changes. The sequence shown here works with the Threshold option (Image>Adjust>Threshold). This photograph has many graphic possibilities (above). The first step is making a Duplicate Layer, and then opening up the Threshold dialog box (right). The slider can be moved for varying effects; here's the variation I chose (above right). Because this is on a dupe layer I could use a Layer Mask. I clicked the Layer Mask icon at the base of the Layers palette, which placed the mask into the dupe layer. I then chose a brush and painted back the threshold effect using different opacities to vary the mask depth and effect. Note the Layers palette showing how I painted the mask (opposite page, far right).

TONING AND COLORIZING MONOCHROME IMAGES

The image color of even a conventional black-and-white silver print is rarely black, white, and grayscale shades. It may be warm (golden), cold (blue), or toned (sepia or magenta). The image color of a monochrome print is one of the keys to its beauty, and the digital realm provides many ways to add color effects.

EASY COLOR OPTIONS

A quick way to add color to a neutral black-and-white image is to go to Image>Adjust>Variations. Before you do this, however, create a Duplicate Layer of the image so you have access to all the modifiers a Layer offers. You are then presented with a choice of numerous color shadings, which you can control to a good degree in variations with the shadow, highlight, midtones, and saturation options. Once you have made your choice, go to the Layers palette and play with opacity. One of the advantages of this method is that you can play with the various tonal areas, fill or reduce the colorization of each one, and see the effect of your choices immediately. You can also create a Layer Mask and change the color effects.

Another simple way is to create a New Adjustment Layer>Hue/Saturation and play with the sliders. When you do, always check the colorize box. The range of colors you can put into an image with this box is nearly infinite, and you can also modify it and use Layer Masks as well.

One of the easiest ways to add image color is with the Variations tool (Image>Adjust>Variations). As you make selections you get to see the original and the changed version. I used this tool to give this set of silos a slight sepia tone.

CHOOSE THE MODE

There are two choices when working with black-and-white images. One is to use the grayscale mode and the other RGB, or color mode. For most purposes, you will want the image to be in RGB mode. If you scanned in grayscale mode simply go to Image>Mode>RGB to convert it to a form that will take the color we are going to give it. Even though your image looks like monochrome or black and white on the screen, you are now working with a color-ready file.

Just what image color is right for your prints? The nearly infinite variables can be maddening at times, but think of them as creative options. As you work you will begin to get a feel for what works for your eye and for the image at hand. The only limitation is your ability to open up to new image-color possibilities. Here are four possible treatments of the image color in this photograph.

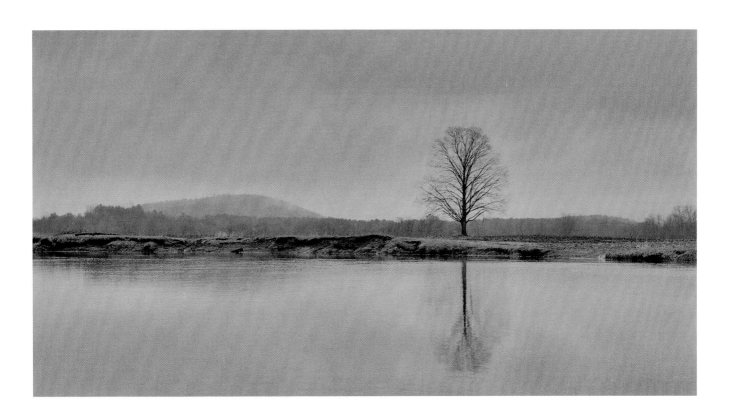

You can paint back or modify a colorizing effect with a Layer Mask. I converted this grayscale image from a 35mm scan to RGB mode and then, using Variations in a Duplicate Layer, gave it a warm-brown, sepia effect (top). I then created a Layer Mask for the Duplicate Layer and painted back some of the image (middle) with a brush set at various opacities (from 20 to 100 percent). I modified the final image using burn and dodge techniques on another Duplicate Layer (bottom).

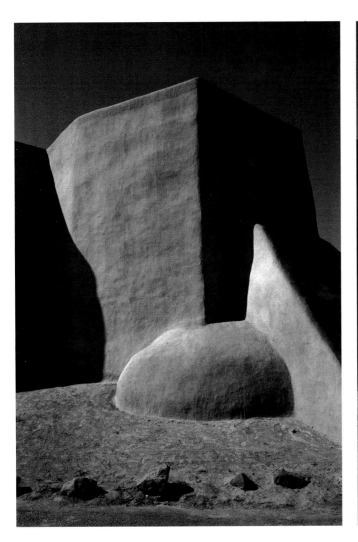

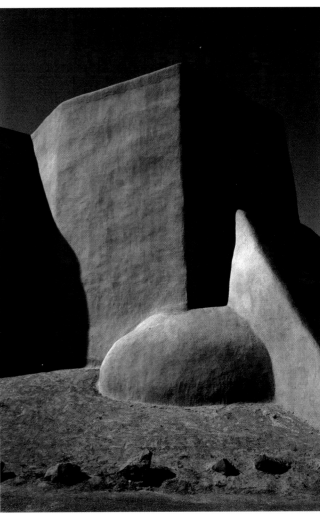

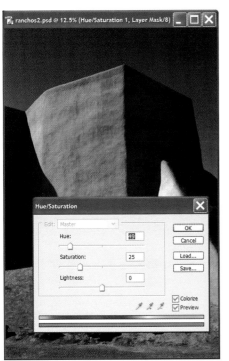

An easy way to add a toned look to a grayscale image is via the Hue/Saturation route. Hue/Saturation exists as an Adjustment Layer, so it allows for many modification options. The dialog box is fairly straightforward, allowing you to choose Hue (the overall color), Saturation (the intensity of that color), and Lightness (which is so sensitive that I tend not to use it, but is fine for a little tweaking). I made these different interpretations with ease using the Hue/Saturation control (left). Since you're using an Adjustment Layer, you can work with Blending Modes, Masks, and the Opacity slider for nearly infinite color and density variables.

One of the easiest ways to emulate silver-print toning effects is to work with Image>Adjust>Variations, which you can do on a Duplicate Layer for even more control. The first step is ensuring that the image is in RGB mode. The Variations dialog box offers many options. Here I have created a warm tone and a cool tone interpretation via the Variations route.

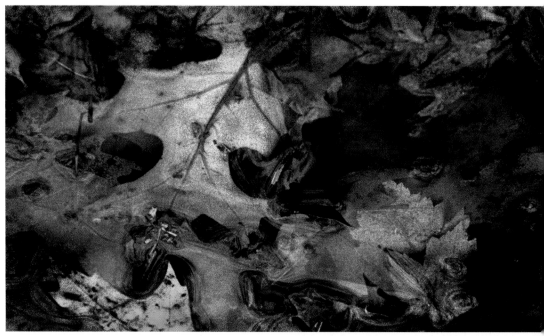

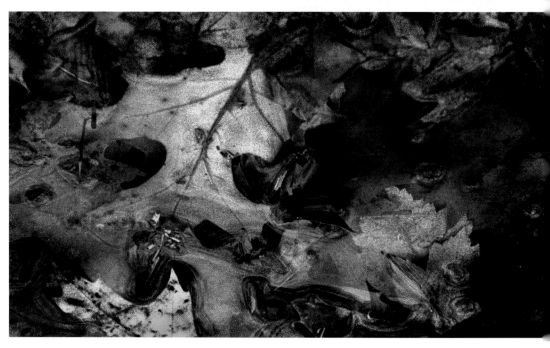

DUOTONES

Among the many ways to add color is to create a duo-tone. Make sure you are working in grayscale mode, then go to duotone, in Mode>Duotone. When you do this, the duotone dialog box will appear. Here you can access different inks for the mix by clicking on the box at the top and choosing duotone (two inks), tritone (three inks), or, for the truly brave, quadtones (four inks).

Let's say you choose tritones. In the three boxes that appear you will select the color inks you are going to use. A color picker shows up as soon as you click on any of the boxes, allowing you to set the colors for your mix. Leave the first box as black, then work your way down through lighter shades. If you want to create a sepia-toned image, you might start with black, then choose a warm yellow, and finally a warm gray. If you want a browner tone, you might choose a light magenta gray for

the lower color. As you make these selections you'll see the color of the image change. If you want to try out some presets, or "canned" duotone, tritone, and quad-tone combos, click on the load button in the dialog box. You'll get a set of folders with presets you can try out on your image. If you like one of these preset choices, re-name the set so you can identify it easily the next time you visit the folders.

After you have selected colors, you can change the curve of the color, or how it is laid down in all the tonal areas of the image. If you click on the Curve box next to the color, you can manipulate the curve at will, changing the way ink goes into the various tonal areas. If you do this on a Duplicate Layer you can modify the image with all the Layers tools at your disposal. You can even do split toning here, a technique in which different tonal areas get different color sets and intensities.

Duotones present the most possibilities for color variety, as you can change both the color (through various ink combinations) and the intensity of each color by manipulating the accompanying curves during ink lay down. I am not sure just how many combinations this might yield, but my guess is that it's somewhere in the millions. Here's the ink setup box that opens when you choose Image>Mode>Grayscale>Duotone (left). If you click on the accompanying curve box you get this screen, which allows you to play with the distribution of a particular ink in the various tonal areas of the print (below).

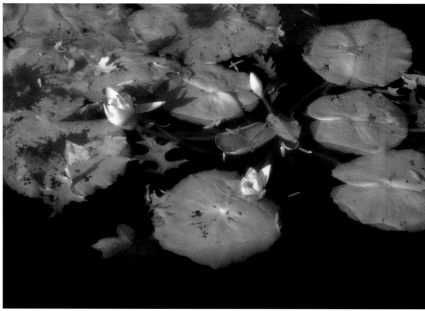

Photoshop offers a number of Presets, or ready-to-use duotone ink and curve combinations. To access them click on the load button in the Duotone dialog box. This set resides in the Tritone folder; there are also folders for duotones and quadtones.

CONVERTING COLOR TO BLACK AND WHITE

I use lots of color images to make black-and-white prints. In fact, color slides are a great source, as they usually are exposed so that the highlights are well under control. When you scan a color image for black-and-white printing, keep it in RGB mode. The best tool for converting color to black and white is called the channel mixer, which you can choose as a new Adjustment Layer. When you open the channel mixer you are presented with a box with various sliders. The first step is to check the monochrome box, which will present a preview of the image in grayscale. This does not convert it to grayscale mode but just presents it as a grayscale version of the image.

The sliders allow you to customize the look of the black-and-white rendition of the image. I find that red and blue affect contrast, while the green affects luminance, or brightness. As you play with the sliders you'll get a good feel for how they change the image. I generally drop back on the red and blue and increase the green.

There are other conversion options, including using Image>Mode>Grayscale to convert an image to grayscale, or Image>Adjust>Desaturate, which removes the color but keeps the image in RGB mode. Note that when you convert RGB mode to grayscale you cut down the image file size by a third without sacrificing resolution. You might want to do this if you have a slow computer or your file size is so huge that even a speedier computer drags along. You can always revert back to RGB mode for printing later, if need be. I usually keep all my black-and-white images as RGB images throughout the process all the way to printing.

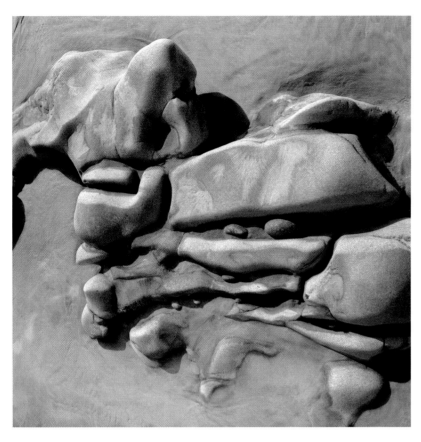

Duotones (and tritones and quadtones) allow you to tweak image color and density to an incredible degree and allow for refinements that will satisfy the most demanding printer. This photograph can be interpreted in numerous ways. Here's a quadtone set and curve off the neutral gray (second ink) (above), as well as the result. One change in the inks or curves would offer a different interpretation.

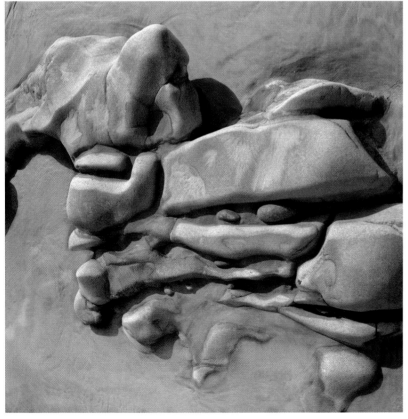

COLORIZING TECHNIQUES

You can also add a touch of color to a select portion of an image or convert color images to black and white that have just a trace of color. You can even hand paint your images and give them the look and feel of old postcards, colored daguerreotypes, or hand-colored portraits. There are many ways to achieve these effects.

If you are aiming for a hand-painted look, the first step is to create a color wash, or foundation, that will serve as the undercoating of the image. Warm brown, lightly applied, usually works best. To apply this wash, first create a Duplicate Layer of a black and white in RGB mode and go to Image>Adjust>Variations and choose your color base. Drop back the effect using the Opacity slider in the Layers palette.

Now choose a few colors from the color picker and place one in the foreground color box, then toggle to the background color box and place one there. This way you always have two colors on your palette. Start to paint, adjusting the opacity of the color between 10 and 20 percent for each stroke. This creates transparent colors, just as if you were applying photo oils to a traditional print. If you need to switch colors, double click one of the color boxes and move on to the next set of colors.

Another option is to create a Duplicate Layer with Hue/Saturation, apply a color through that dialog box, then add a Mask and paint back to the original color. Or, you can blend colors by setting the opacity below 100 percent. You can then create another Duplicate Layer and color that. Each Layer is like an acetate onto which you add or peel away color as you please.

Emulating hand-coloring and split-toning effects in digital is quite easy, and opens the door for many graphic interpretations of black-and-white prints. This photo started out as neutral gray converted to RGB (right) and then, after I used Variations (below) on a dupe layer, became a warm-tone image (opposite, top). I then used a Layer Mask (opposite, top right) to paint back part of the color from the scene (opposite, middle); zooming in helps me work in small-detail areas (opposite, bottom right). The final print (opposite, bottom) is much more evocative of the mood of the scene.

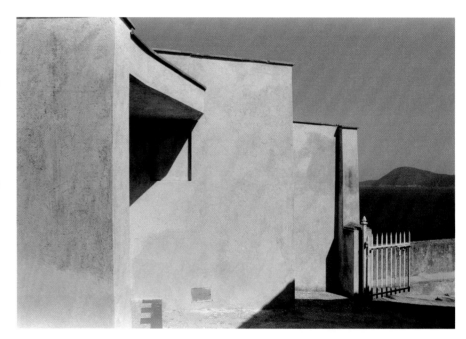

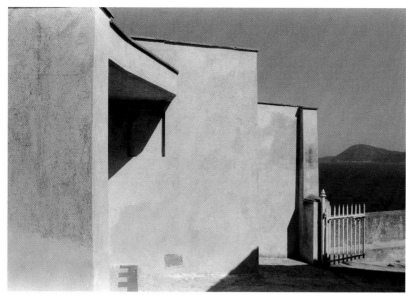

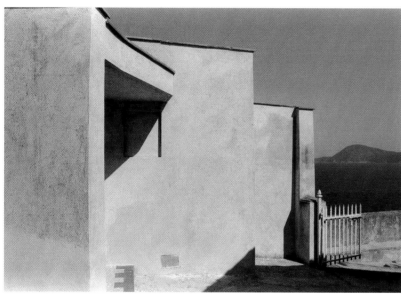

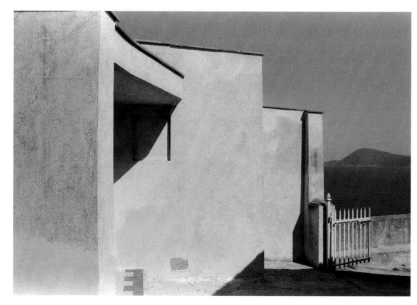

There are many ways to add hand-coloring effects. Perhaps the most important concepts are to work with paints at low opacity and to work lightly, keeping in mind that you can always vary exposure and color richness later using Levels and Hue/Saturation Adjustment Layers. This forest scene is prime for hand-coloring effects (right). The first step is to choose prime colors with which to work. I work with two colors at a time by using the Foreground/Background color boxes. I click on the Foreground color box to bring up the Color Picker (below) and then follow suit by toggling on the boxes and choosing a background color. Here I have chosen a light yellow and soft green as my two prime colors (below). When I start work I just toggle between the two. I work loosely with a soft-edged brush and vary the brush opacity as I go, but never exceed 20 percent, as this will paint over details (right, bottom). I can always change the intensity of the colors later. Here's a stage of the work after I made a change in Levels to increase color richness through contrast (opposite, upper left). I then opened the Hue/Saturation control (opposite page) on an Adjustment Layer and shifted the colors toward a deep blue (opposite, upper right), knowing that I was going to paint back much of the scene away from that tint. The final shows the influence of the blue tint and how I masked it using various opacities on the brush used for the mask. To show how another adjustment can affect the image, I added another boost of color through Hue/Saturation (opposite, bottom).

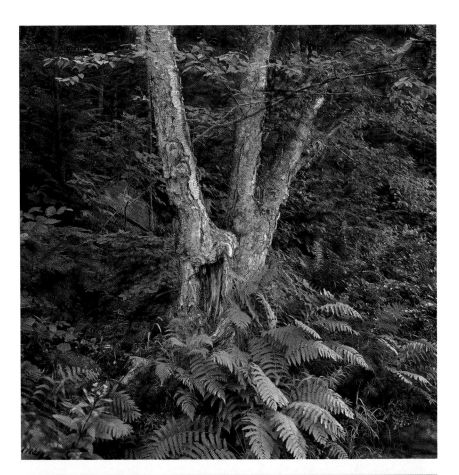

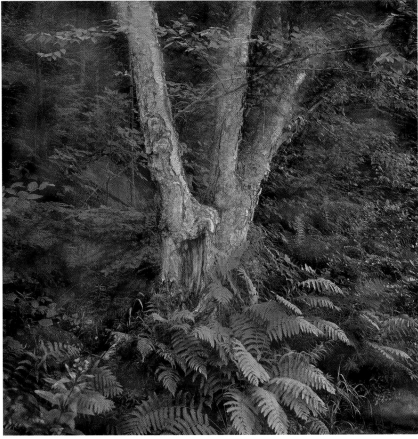

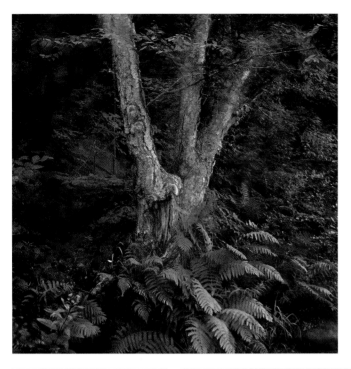

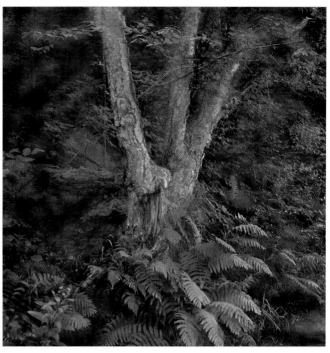

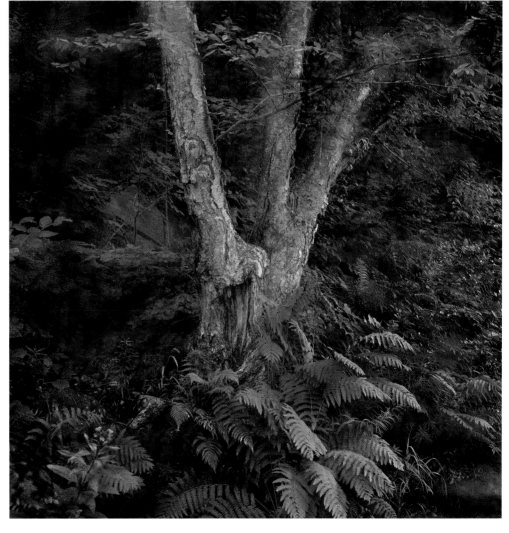

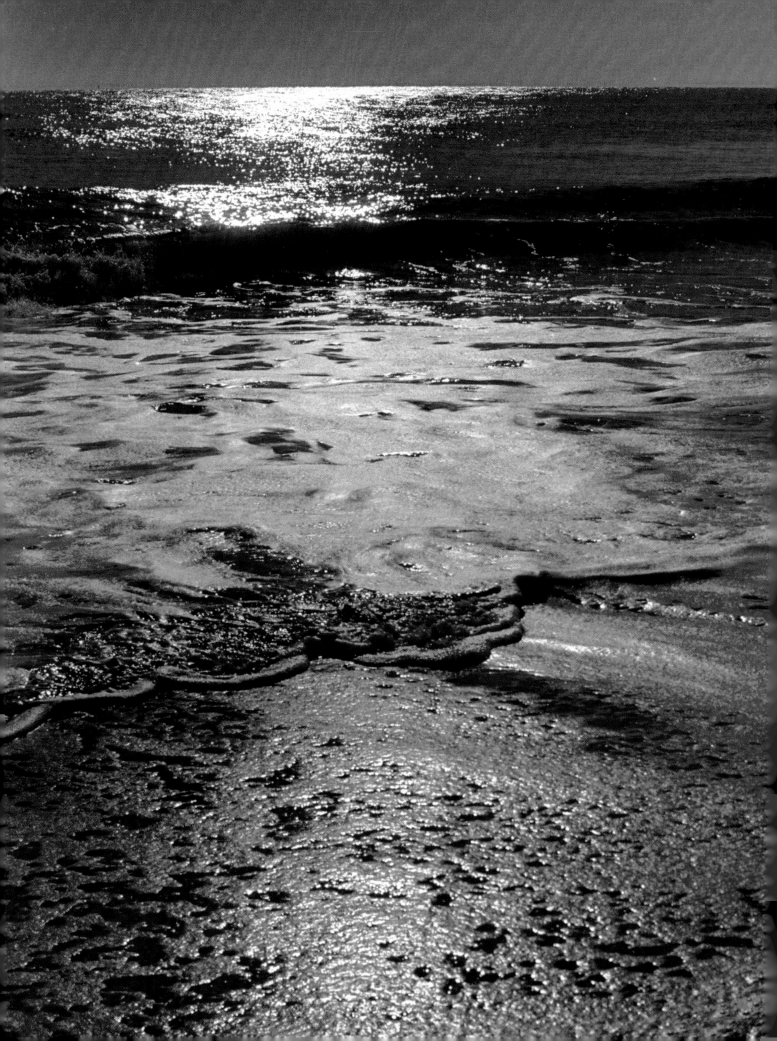

PAPER AND INK

Choosing the right paper and ink, and setting your printer to accommodate them, is a crucial step of digital printmaking. As with the conventional darkroom, the choices of materials are broad, making it easy and exciting to create beautiful prints.

Paper for Your Printer

Ink Options

Printer Setup and Settings

PAPER FOR YOUR PRINTER

Your choice of printing paper will have a profound effect on how your image prints. Fortunately, you have a wide choice of papers, from glossy to matte, to silk to canvas, on which to create your prints.

An inkjet printer creates an image composed of dots that are literally sprayed onto the paper. These dots are very, very small and are placed with amazing accuracy. The density and placement of these dots are what create the illusion of a continuous-tone image. Each paper you use will require a different amount of ink and will receive the ink in a different manner. Some papers are more absorbent than others, some require a very fine layer of ink, and others require heavier placement.

The paper must be treated in such a way that the sprayed dots coat it with a minimum of diffusion. In addition, the ink and paper should work together so that the ink does not smudge or require a very long time to dry once it's applied. You will find that printing on different papers might result in different tonal and image color variations. This can be slight in some combinations, fairly far off in others. Matching ink and paper can be a daunting problem, one that is often solved by sticking to a few ink and paper combinations and learning their foibles and how to tweak them for best results.

HOW LONG WILL YOUR PRINTS LAST?

Papers and the inks you use on them will largely determine the long-term stability of an inkjet print. Recent developments in dedicated inkjet paper, along with specific ink sets, have created ink/paper combinations with the longevity of standard photographic paper.

Two-hundred-year pigmented ink and paper sets are now available, as are seventy-year-plus dye-ink sets and papers. Some papers and inks, however, don't even come close to these standards, so awareness is important. Keep tabs on web sites dedicated to inkjet printers or type in "inkjet printers archival standards" on a search engine. One such site is www.wilhelm-research.com. Henry Wilhelm and Carol Brower have been studying image permanence on photographic and inkjet papers for years, and their web site is an invaluable resource for digital printers who want to make inkjet prints last.

The first step when working in Photoshop is to make the color settings, which you need do only once. Go to Edit>Color Settings and make sure that the working space is Adobe RGB and the "Settings" is U.S. Prepress Defaults. Also, keep the "Preserve Embedded Profile" boxes checked, and work with the embedded profile of your image.

To help ensure that the print you make will be as close as possible to what you see on the screen, go to View>Proof Setup>Custom and match the paper and printer. Choose different proofing setups and see how your image changes accordingly.

This message screen may come up if you have chosen Adobe RGB as your working space and open an image from a digital camera, which may have a default working space of sRGB—more color rich but somewhat more confined than RGB. If you change the embedded profile you might shift the values or colors more than you desire, so in general maintain the profile as recorded.

PAPER SURFACE EFFECTS

Paper surface and base color have a profound effect on an image. Just as in conventional photographic printing, an image generated with an inkjet will look different if it's printed on glossy or matte stock, or if that stock has a brilliant white or cream base color. I often print duotone or sepia images on warm paper stock to enhance the image. I rarely print natural scenes on glossy stock, but I always print commercial or work for repro on it. Your personal choices will be based on taste and tests.

More and more varieties of inkjet papers become available all the time. Here's a quick review of some of the inkjet papers I have used.

- Glossy, photo-quality inkjet papers are commonly used for printing color prints, snapshots, and black-and-white commercial work and for scanning from prints for reproduction. This paper provides a sharp rendition, which may be good or not so good for the image. The effect may be too contrasty for some work and it may eliminate some tonal subtlety, but it yields the deepest black and whitest white. This is my paper of choice if I am doing prints that will be scanned for repro (for newspapers and magazines)—but that's become a rare occurrence, since now I usually just submit electronic files for reproduction purposes.

- Matte heavyweight, photo-quality inkjet papers tend to tone down contrast yet still deliver an excellent tonal edge and are often my first choice. The matte surface holds the ink as well as glossy stock does and is most suitable for nature, scenics, and even some portraits. Blacks are deep and whites are bright but not as deep or brilliant as with glossy stock. So, this paper is probably not suitable for commercial work in which the print will be scanned for reproduction, for illustration work, or for some portraiture. Variants on this surface, sometimes described as "silk" or "pearl," have many of the image characteristics of matte but have a shinier finish and can reproduce luxurious tones.

- Canvas and textured papers do not, as a rule of thumb, work well with inkjet printers, but some papers with textured surfaces are designed to hold the inks well. In general, I find that papers with too much texture or weave tend to obscure the details in the print, but they can be fun to work with.

- Fine art papers come in a variety of weights and surfaces. Many add a luxurious feel to inkjet images and, because they are usually acid free, aid in the image's longevity. They are considerably more expensive than stock or standard inkjet papers but may be worth the price for certain select images or editions.

- Generic art papers, used for standard printing, may be used for inkjet printing if they are coated properly; check with the seller or distributor. I have had very good luck with some of these papers and enjoy the variety and selection. Most come in a variety of shades and base colors as well. Unfortunately, these papers do not offer the long-term stability of some of the other papers.

- Special effects surfaces include fabric (silklike material), transparent sheets, and other types of media. This option may be attractive to photographers who use images for multimedia projects or who just want to experiment.

- Budget options are the low-priced papers usually found at discounters and office superstores. Be aware that some of these inexpensive papers may not provide the quality you desire and might not last very long; the life spans of some are as short as one or two years, after which colors and tones may fade. But you'll save money using them if you just want to experiment and use the prints as proofs.

SETTING	MEDIA TYPE	PRINT QUALITY	COLOUR
E1	Premium Glossy Photo Paper	720 or higher / High Speed: ON or OFF	Automatic
E2	Photo Quality Glossy Film	1440 or higher / High Speed: OFF / Supermicroweave: ON	Automatic / –5pt Magenta
E3	Photo Quality Inkjet Paper	1440dpi / High Speed: OFF	Automatic
E4	Photo Quality Inkjet Paper	720 or higher / High Speed: ON or OFF	Automatic
E5	Photo Paper	1440dpi / High Speed: OFF	Automatic
E6	Photo Paper	360, 720 or 1440dpi / High Speed: ON or OFF	Automatic
E7	Premium SemiGloss Photo Paper	Photo	Automatic
E8	Premium Photo Paper	1440dpi	Automatic
E9	Archival Matt Paper	Fine / High Speed: OFF	Automatic
E10	ColorLife Photo Paper	1440dpi / High Speed: OFF	Automatic
E11	Watercolor Paper - Radiant White	720 or 1440dpi	Automatic

11/2003

INK OPTIONS

The image color of a monochrome print is one of the keys to its beauty, one that a discerning eye will always appreciate. New inks are enhancing image-color possibilities considerably.

The color possibilities the digital darkroom provides are very exciting, and the ink options available to you make digital printing especially expressive. These options extend to black-and-white inkjet prints, which can be toned sepia, brown, and even blue for various image effects.

I generally use the inks made by the printer manufacturer, since ink nozzles are geared toward working with a specific consistency of ink the manufacturer provides. A growing number of optional, third-party inks are also available, and these include grayscale sets that come in neutral, warm, or cool versions. I have had fun and gotten very good results with some of these inks, although they do require a special setup when you use them, called "profiling" (see page 154). It's a good idea to dedicate a printer to these inks, or you'll need to clean the nozzle heads each time you use them with other inks; be sure to follow the cleaning instructions and use the third-party ink manufacturer's cleaning cartridges. Remember, too, that most printer manufacturers will void your warranty if you use a brand of ink they don't recommend.

CHOOSING MODES

You can print black-and-white images in two modes: grayscale mode and RGB, or color mode. You can work with either, depending on how your printer performs. Some printers yield fine prints, while others produce satisfactory prints only in RGB mode. You have to test to determine the mode in which your printer yields the most satisfactory results. If you have converted your grayscale file to duotone or have scanned a toned image into RGB, then you must work with the printer in RGB mode. That's how I do most of my printing.

When you use printing papers other than those supplied by the printer manufacturer, it is a good idea to locate and load the paper profiles, as they will not otherwise appear in your printer driver settings. Some paper companies might supply you with settings that are equivalent to those used by manufacturer brands (opposite page) or have profiles available for downloading on their web sites (above). Here are two such offerings from Ilford, a company with a great reputation in the photographic and inkjet-printing-paper business.

PRINTER SETUP AND SETTINGS

In a few easy steps, you can set up your printer to handle your digital images so it produces the highest-quality prints.

When you're ready to print and open the image on your screen, do a Save As and work on a copy of the original—this way, you'll always have a backup if the file is written over. This step is unnecessary if you are working from a CD or DVD.

Then, if you have not done so before, make sure the Color Setting on your monitor is set correctly at U.S. Prepress (go to Edit>Color Setting in Photoshop and use the drop-down options to make this choice). In the same dialog box choose the working space, which for most images will be either Adobe RGB or sRGB. (Note, some digital cameras are set at sRGB as a default while more advanced digital cameras allow you to choose between the two.) Choose Adobe RGB for most work.

Then, to ensure that the image on the screen matches the output from the printer, plug in your paper profile. You do this by going to View>Proof>Custom and dropping down the choices to find the paper and printer on which you will be printing. If you do not see your paper, you'll need to load a profile (see page 154); if you don't see your printer, you'll have to load your printer driver software.

The Image Size dialog box allows you to put in the desired print size and to set the resolution for the best possible print. This box shows an image that was scanned for 400 dpi output (above left) and has more resolution than necessary for a quality print.

Here, I've opened a 16.9 MB image at screen resolution 72 dpi (above right). The print size is very large, but I would produce an awful-looking print. So, I've changed the resolution to a good dpi for most desktop printers, 240 dpi (opposite, upper left). Note that the print size now becomes 8 x 12½ inches, as resolution and image size are interdependent. If we bring the resolution up to 300 dpi we lose some print size, down to 6½ x 10 inches (opposite, upper right). It is possible to break the strict interdependence of the two factors via a process known as resampling, but there is a rule of diminishing returns if you resample too high. Here I have resampled the image to squeeze some more size out of a 240 dpi resolution (opposite, bottom).

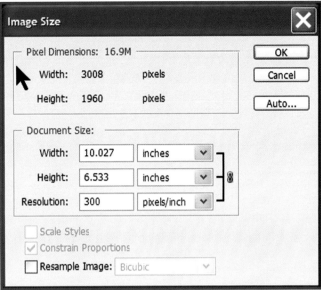

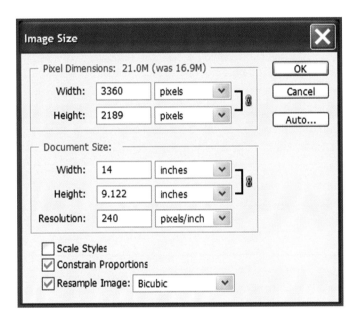

PRINT SIZE AND RESOLUTION

The next step is to make sure you set up the image so it has the proper resolution for your printer. You do this in the Image>Image Size dialog box. Open any image on the screen and open the Image Size dialog box. Here you'll see the number of pixels that compose the image, the file size, and the resolution of the image itself.

When you first open the image you might see a screen resolution of 72 dpi (most digital cameras yield images at this resolution number). You must change this number to print. If you don't change the number, your image will be quite large, but will break up—a resolution of 72 is too small to yield a good print. Change this number to 300 dpi or 240 dpi (a good number for most printers.) If you scan from film you can change this number during scanning.

When you input the new resolution number, the image size will decrease. If the image is smaller than you'd like it to be, you can resample, or interpolate, the image information. To do this check the resample box at the base of the image-size dialog box. As you change the size at the same resolution you'll see the file size grow, but since you are not adding new image information, at some point the image will start to degrade. That is, the image may not have enough pixels to stand up to enlargement. When I resample in Photoshop I do so in increments of about 10 to 20 percent. Special resampling tools are available, but I have gotten the same results using this step-by-step method.

Click OK to accept the new resolution and image size and go to the File menu and scroll down to Print. The Print dialog box will open up, and you will be prompted to set certain components, outlined below.

PROFILING

A profile tells the printer how much ink to lay down when using certain kinds of paper, and is specific to a particular ink-and-paper combination and to the printer you are using. Print on glossy paper with matte selected and you'll have poor ink lay down, which may result in muddy colors and pooling that will not dry correctly. Choose glossy with matte paper loaded and the results might be thin with poor coverage. If you use the printer manufacturer's brand of paper for your specific printer, there's a good chance that the profile is already loaded in the printer driver.

You can find the profile for the specific ink, paper, and printer you use on most paper company web sites under the Resources or ICC Profile heading (this information is also included on some paper packaging). You then download the profile and copy it into your operating system. In some cases the company might recommend equivalent settings that are matched to printer brand papers.

In general, here's where you load the profiles; make sure to read the instructions for your system carefully and follow any other instructions on the web site before you download the files.

- In Windows 95/98/98SE and ME operating systems: C:\Windows\System\Color folder

- In Windows 2000 and XP: C\WinNT\System32\Color folder

- In some Windows XP systems: C:\Windows\System32\Spool\Drivers\Color folder.

- In Mac OS X: Users/Library/ColorSync/Profiles

- In Mac OS 9: System Folder: ColorSync Profiles

- In Mac 8.5 and earlier: System Folder: Preferences: ColorSync Profiles

By the time you read this there may be new versions of operating systems or changes in the way these profiles should be loaded; so, if your printer isn't laying down ink properly, check with the manufacturer.

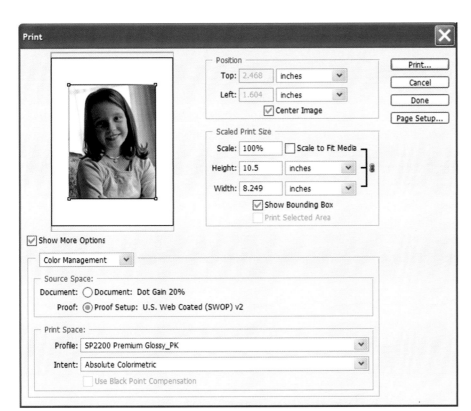

When you get to the actual printing stage, begin with File>Print with Preview. The dialog box ascertains your initial settings and allows you to modify them as required. Always check the Show More Options or Advanced box. Here are the settings for an Epson 2200 printer.

If everything is set in the Print with Preview box, click on the Print button and you will enter the printer driver settings box. This serves as the access to the Properties dialog box.

PRINTER SETTINGS

When you're ready to print, go to File>Print with Preview. Make sure that the size of the paper you are using (8.5x11, Letter, 11x14, etc.) matches the indications in this box. It's important to check each time you print, as it may revert to a default setting that does not match the size paper you might be using at the time. If you always use one size of paper, change the default to that size.

Next find the Color Management section, which you might have to open by clicking on a box that says Show More Options. If you set the printer up correctly, everything should be set here. If not, change the settings.

You're now ready to hit the Print button. You can save the settings and call them up when you go to print the next time (using the Save Setting button in the Properties dialog box). But don't be afraid to play with these settings and to experiment with different types of images on various papers. For the most part, however, sticking with one or just a few different paper types, and learning how to get the most from them, is the best course.

Many print drivers will create a checklist that may have more or less information than shown here. In many cases you can save the settings, name them (such as "fine art matte" or "commercial glossy"), and load them later so that you don't have to go through this whole process every time you print.

Current Setting

Paper Source: Sheet
Paper Type: Premium Glossy Photo Paper
Quality: Photo - 1440dpi
Paper Size: A3 (11.7 x 16.5 in)
Orientation: Portrait

Modified Advanced Settings
None

Close

Again, double check all your settings here and make sure they match the size of the paper, the paper surface, and the printer. Perhaps the most important thing you might have to do here is to make sure that you've checked No Color Adjustment or No Color Management. This ensures that there is no conflict between Photoshop and print-driver color settings.

If you have trouble with your printer, the nozzles may be clogged (a sure thing if you don't use the printer regularly) or the heads may need alignment. Click on the Maintenance button to run the machine through some diagnostics.

GLOSSARY

Adjustment Layers: A collection of filters, each of which can affect nearly every pixel in an image. They allow you to convert color to black and white, alter contrast, change exposure, etc., and each allows you to nuance, or turn down, any effect.

Bit: A binary digit that is the smallest piece of information used by a computer.

Bit Depth: In imaging, the number of pixels used to describe pixels. The greater the bit depth the more information is described.

Blending Modes: Tools that increase exposure (Multiply), decrease exposure (Screen), change contrast by about one step (Overlay), and more.

Brightness: The luminance of objects. The brightness of any area of the subject is dependent on how much light falls on it and how reflective it is.

Burning: The selective increase, or darkening, of tonality in certain areas of a scene.

Byte: A group of 8 bits, used by the computer as units of information.

Channel Mixer: A highly effective tool for converting color to black and white.

Color Balance: A setting that matches the available or artificial light and faithfully renders color. It can also be used to alter the lighting effect and can act as a form of color cast or mood.

Compression: Shrinking a file's size. Some compression schemes discard file information in the process; others do not. The image information is reconstructed when the file is opened again.

Contrast: The relationship between the lightest and darkest areas in a scene and/or photograph. A small difference means low contrast; a great difference, high contrast.

Curves: A tool that allows you to control both the overall contrast and distinct tonal values within your image.

Desaturate: A tool that removes color but keeps an image in RGB mode.

Digital Darkroom: Jargon for image processing programs, papers, inks, and printers used to edit and manipulate digital images.

Digitize: To convert analog (film, print) information to digital form by use of a scanner, digital sensor, or camera.

Dodging: The selective reduction, or lightening, of tonality in certain areas of a scene.

DPI: Dots per inch. The output resolution.

File Format: An arrangement of digital information that may be particular to an application or generally adopted for use by a wide range of devices. Image formats in wide use include JPEG, TIFF, GIF and increasingly, RAW.

Fill: A technique that allows you to bring tonal information into image areas. It does not affect image detail, just tone.

Fill Flash: Fill-in flash, usually used outdoors to balance the exposure of a subject that is backlit.

Filters: In computer-imaging software, a set of instructions that shapes or alters image information.

Flat: Low in contrast. Flat light shows little or no change in brightness value throughout the entire scene.

Format: In memory cards, the type of card, such as CompactFlash, SD (Secure Digital), etc. In image files, the choice of JPEG, TIFF, etc.

Grayscale: The range of tones, from bright white to pitch black, that can be reproduced in a print.

Highlights: The brightest parts of a scene that yield texture or image information.

High Resolution: A relative term that defines the input and output quality of digital images (for example, sharpness, continuous tone).

Histogram: A graphic representation of tonal values that can indicate where to make adjustments.

Hue: Color, as defined by words such as yellow, blue, pink, etc.

Image Processor: The microprocessor in the camera that integrates image information received from the sensor. It can also add image attributes as described by the photographer at the time of exposure.

JPEG: Acronym for Joint Photographic Experts Group. A type of graphics file format that is often used for compressing large image files for transmission or display.

Layer: In image manipulation, an effect that is superimposed on an image that does not change the underlying pixels.

Layer Mask: A modification of a Layer that works by erasing some of the overlying Layer to reveal the Layer information underneath.

Layers Palette: An information area that shows the background, or original image, and the various other Layers you have created. It can also be used to modify various Layers as needed with Opacity sliders, Blending Modes, and more.

Levels: Displays the contrast range and allows you to modify it, then redistributes the tonal values throughout the image.

Memory Card and Memory Card Reader: A memory card is the common name for a PCMCIA, CompactFlash, SD, Memory Stick, xD, or similar type of card used in a digital camera. A memory card reader is a small device that patches right into the computer for easy downloading.

Microprocessor: A combination of transistors that performs specific operations. Microprocessors are found in computers and all digital cameras.

Multi-sampling: Making two or more scans of the same image.

Noise: A random pattern of pixels that interferes with an image. Usually associated with low light, long exposure, or high ISO images.

Overexposure: In exposure, when too much light strikes the sensor for a proper rendition of the scene.

Pixel: The picture element that forms the basis for digital imaging.

Pixel Resolution: The pixels per inch in an image, such as 640 x 480.

Plug-ins: Software that supplements image effects offered in standard image-editing and manipulation programs.

Usually affords special effects and specific tasks with push-button ease.

PPI: Pixels per inch, the basis for figuring image size, file size, and, ultimately, image quality.

RAM: Random access memory. The memory that stores data as an image is being worked on. For image processing, the more RAM the better.

Raw: A proprietary image file format. Raw is the image information as delivered by the sensor and is not extensively processed in the image processor of the camera.

Resolution: In digital imaging, the number of pixels per inch (ppi) in an image.

RGB: Red, green, blue. The channels that make up a color digital image.

Saturation: In color, a vividness, or intensity.

Step Wedge: A representation of the grayscale spectrum of tonal values that shows how these might break, or become distinct, on the print.

Stop: A relative measure of light that can be used to describe an aperture or shutter speed. A difference of one stop indicates half or double the amount of light.

TIFF: An acronym for Tagged Image File Format. An uncompressed file format.

Tonality: The quality of light in a picture. Tones are the range of dark to light that make up the recorded image, and may or may not match the original brightness values in the scene.

Tone Curve: A graph used in digital photography that displays tonal range, which changes when the curve is manipulated.

Variations: A tool that allows you to alter color, saturation, and other qualities with one click.

INDEX